# 2ND

## THE FACE OF DEFEAT

photographs by
**SANDY NICHOLSON**

foreword by
**SUSAN BRIGHT**

M

For the winner in all of us.

# IT'S NOT THE WINNING BUT THE TAKING PART

*by*

SUSAN BRIGHT

*These portraits are as poignant as they are amusing.* Coming 2nd,
I began to think as I looked at these photographs, is better than
coming 1st. No room for exaggerated egos or inflated boasting, but
a place for pride, inevitable disappointment and a determination
to do better next time. There is something a bit more human about
the conflicting and contradictory emotions that coming 2nd evokes—
being the runner-up is something we can all relate to.

Photographed mainly in Canada, the competitions represented
here are not world-class sporting events nor the most well-known
jamborees, but the more ordinary. There is the local cat show, rodeo,
Lego-building event and cheerleading nationals. The provincial,
suburban existence of the majority of the entrants is too easily sneered
at by Metropolitans, but celebrated by most. Sandy Nicholson
opens up worlds to us that we may never otherwise have seen. These

are competitions that happen all around, but ones we will never attend if they are not our "thing." Nicholson's photographs show us places where the old adage "it's not the winning but the taking part" may sometimes ring hollow. There is a lightness of touch to the images, however. Nicholson has a love of the graphic, honing in on not just the faces of the participants but the costumes, postures and surroundings that shape their identity.

The value of a hobby is immeasurable for many. It introduces them to new and unlikely people, gives direction to spare time, demands respect and authority that comes only with specialist knowledge, and it offers the chance to connect (both virtually and personally) with a new community of like-minded souls. Simply put, hobbies give people a chance at another identity—one that may be more glamorous than their everyday lives—an escape route into another life. *A tax inspector can also breed chinchillas, a hairdresser can transform into a ballroom dancer or a retired housewife can also be a champion rose grower.* Fantasy and reality, and the excitement and adrenalin of competition are a heady and irresistible combination.

Nicholson's photography is an ethnographic study of sorts; he is a modern day Benjamin Stone. Stone, a British Industrialist, Member of Parliament and amateur photographer, initiated the National Photographic Record, and in 1906 published *Festivals and Customs.* In it, Michael MacDonagh proclaimed: "The work will depict…all kinds of customs and festivals, even some of those which take place only once or twice in a lifetime…Thus it will bring before the vision with actuality and clearness some phases of our national life of which few of us can hope to be eyewitnesses." (*Sir Benjamin Stone's Pictures: Records of National Life and History,* Cassell and Company, 1906, p.vii.)

The vast collection of the Stone archive consists of 22,000 mounted albumen and platinum prints taken from 1870 to 1914, as well as negatives and stereographs. The record was part of a much wider photographic survey movement at the end of the nineteenth century and forms what is now referred to as a visual "memory bank." Amongst portraits of politicians and topographic views of land and buildings, the archive also shows a nation celebrating the customs and festivals of its towns and villages. Somewhat ill at ease with their identity as the new century promises to bring forth change and progress, the people captured by Stone's camera pose tentatively, caught in the crossfire of the old and the new. Nicholson's subjects have grown up with the camera and know almost instinctively how to act. How different also the world has become! Competitions have all but taken over the festivals and fairs as defining a nation's identity. Local pride has all but gone and personal gratification and gain is now the order of the day.

The urge to compete is exacerbated on a national level through television and radio. Now it's nearly impossible to turn on the television without seeing a process of elimination by the audience to proclaim one person, building or artwork the finest. *Reality television makes celebrities out of those we would never usually know (or care) about.* This drive to compete as an individual has taken over the desire to celebrate as a community, and now the same desire for a "winner" can be found in the most banal and everyday events, from local pumpkin festivals to children's Halloween parties.

Like Benjamin Stone, Nicholson doesn't wander far. He's not interested in far-flung exoticism, but in what is nearby. It was Diane Arbus who most famously worked in a similar way, finding beauty in the "freaks" she found on the streets of New York City, usually

just a few blocks from her studio. A love of the "ordinary" infuses Nicholson's work, too. Referring to himself as an "amateur anthropologist," he doesn't adopt a sensationalist gloss nor a distanced forensic gaze, but an "everyday editorial" style that is familiar and approachable. His process, too, shows an egalitarian spirit, treating everyone the same. Nicholson photographs both the winners and those who come 2nd, asking them to pose whilst thinking about the moment they heard their fate. He doesn't tell them about the project until afterward, because if they knew, they would become winners in a way.

This approach leads to a range of emotions being depicted. Some are happy to have come 2nd, while others are bitterly disappointed but stoical. What the photographs do is take the viewer away from the generic "press photograph" that would normally represent the athletes—*the well-worn podium shot or the cheesy handshake and presentation of an oversized cheque.* The wealth of information you glean from just a few seconds of meeting a person is also how we read a portrait, and whether you can deconstruct the information it gives you "accurately" is hard to say. It is then that the quotes with the photographs become important and anchor the image, making the work all the more accessible and adding humour to the pathos.

Gary Delavigne, who came 2nd in the 45+ Ontario Squash Championships, talks not of his performance but the rewards: "My wife was happy with the prize. She has them in the kitchen. Last year, I got some tumblers I think." There is a sense of satisfaction when we find out that Bump Postlethwait, runner-up in the Bull Rider rodeo event, had the strength of mind and the spirit to get back on his horse (or bull in this case) with a broken jaw, drive five hours and get 1st Place in a steer-wrestling competition.

What this series does is both commemorate the world of local competitions and celebrate those who would usually be forgotten. *The winner always becomes famous, but the runners-up are just as remarkable.* Neil Armstrong has been immortalized as the first man to step on the moon, but Buzz Aldrin, who followed, is no less remarkable. The competitions that Nicholson captures may be more mundane than grand gestures of space travel, but they illustrate how the ordinary can be extraordinary, and the fascinating human desire to belong.

The competitions and the journeys they take people on, both physically and emotionally, should be recorded, however the participants are ranked in the eyes of judges. In the words of Cole Manson (Johnny Uta), who came 2nd in the Air Guitar Finals: "There was no way in hell I could lose if I ran up the wall and broke a beer bottle over my head. I was sure I had won, but sometimes the bloodiest guy doesn't always win." In this case, it was most definitely not the winning but the taking part that counted.

January 2008

*Success is getting what you want.*
*Happiness is wanting what you get.*

DALE CARNEGIE

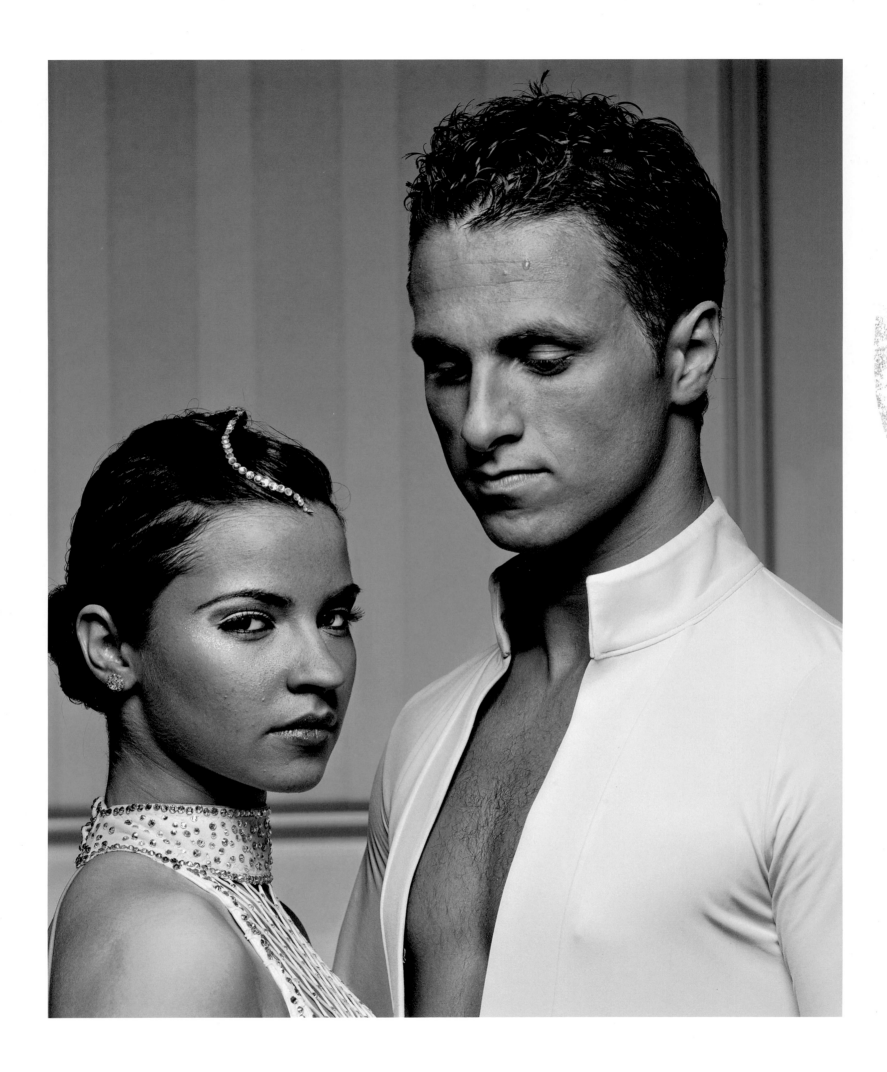

CLAUDIA PRIMEAU-SAUVE & CHRISTIAN MILLETTE
2ND, BALLROOM DANCING, DANCE SPORT CHAMPIONSHIP
DOUBLE TREE HOTEL, TORONTO

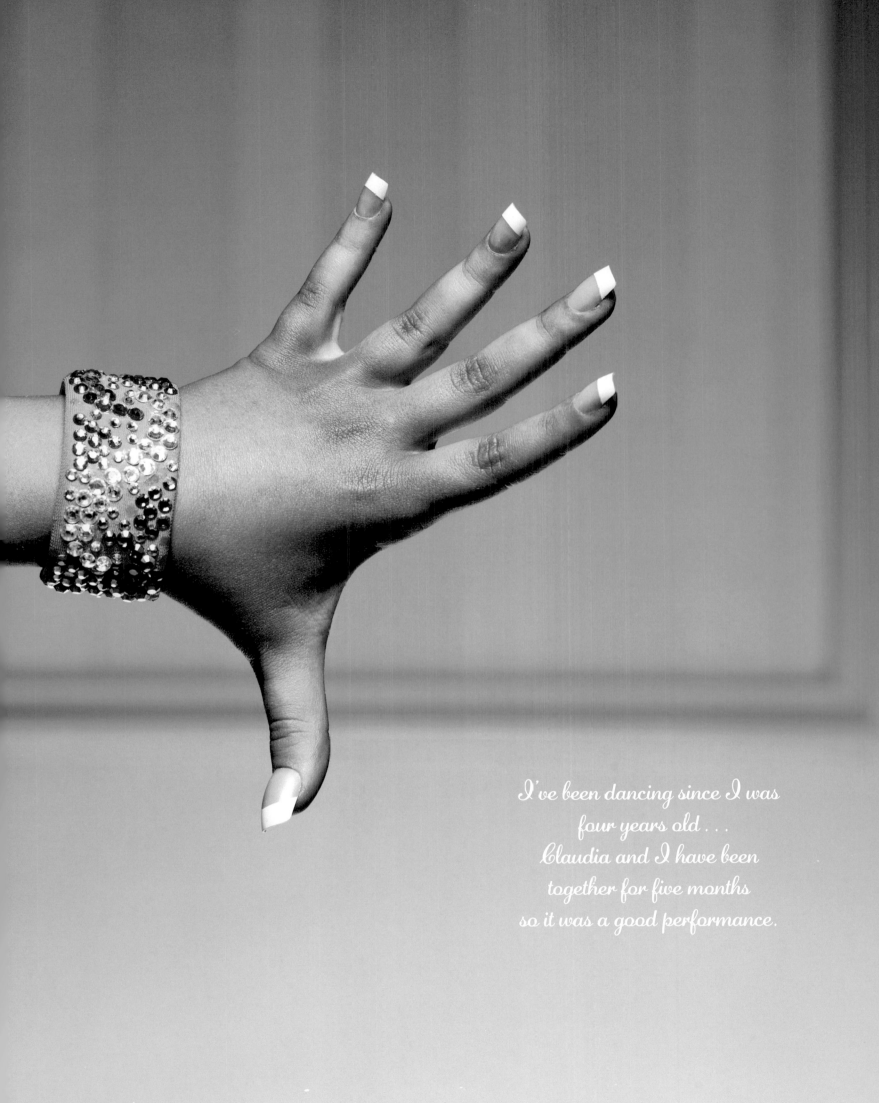

I've been dancing since I was
four years old . . .
Claudia and I have been
together for five months
so it was a good performance.

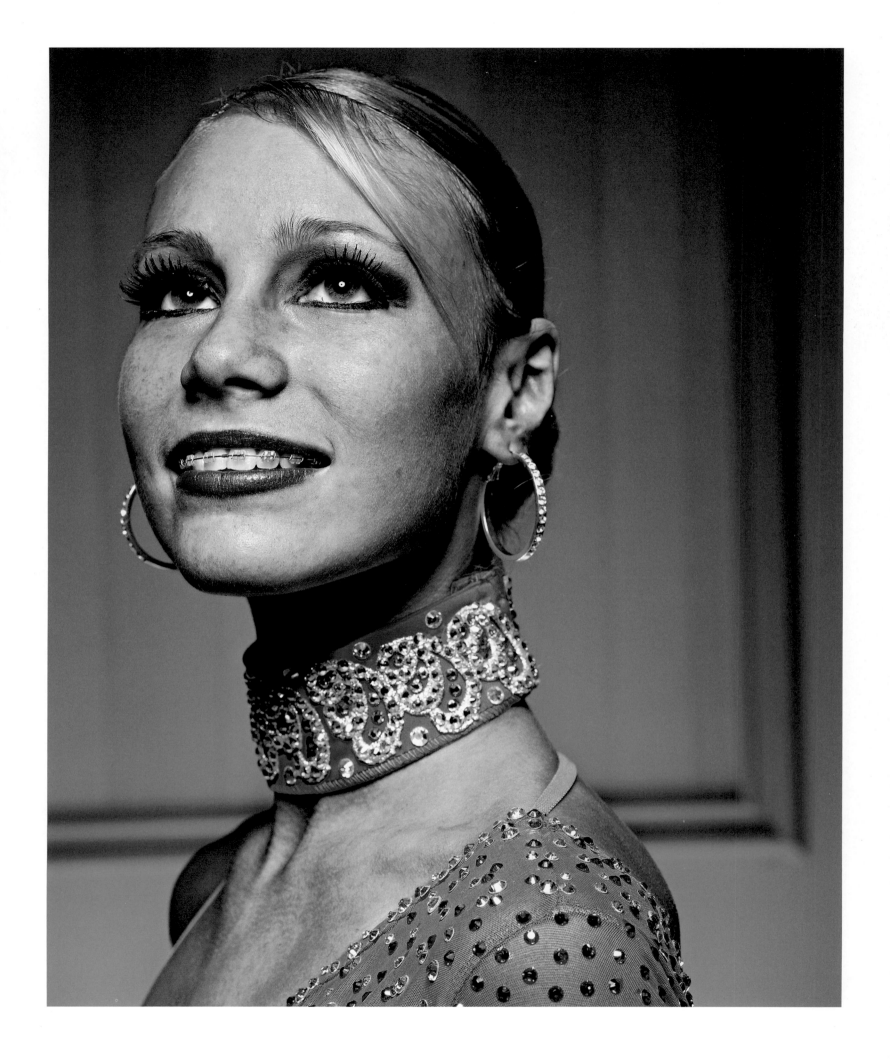

EVQUEUI CHAOULSKI
2ND, LATIN BALLROOM DANCING, DANCE SPORT CHAMPIONSHIP
DOUBLE TREE HOTEL, TORONTO

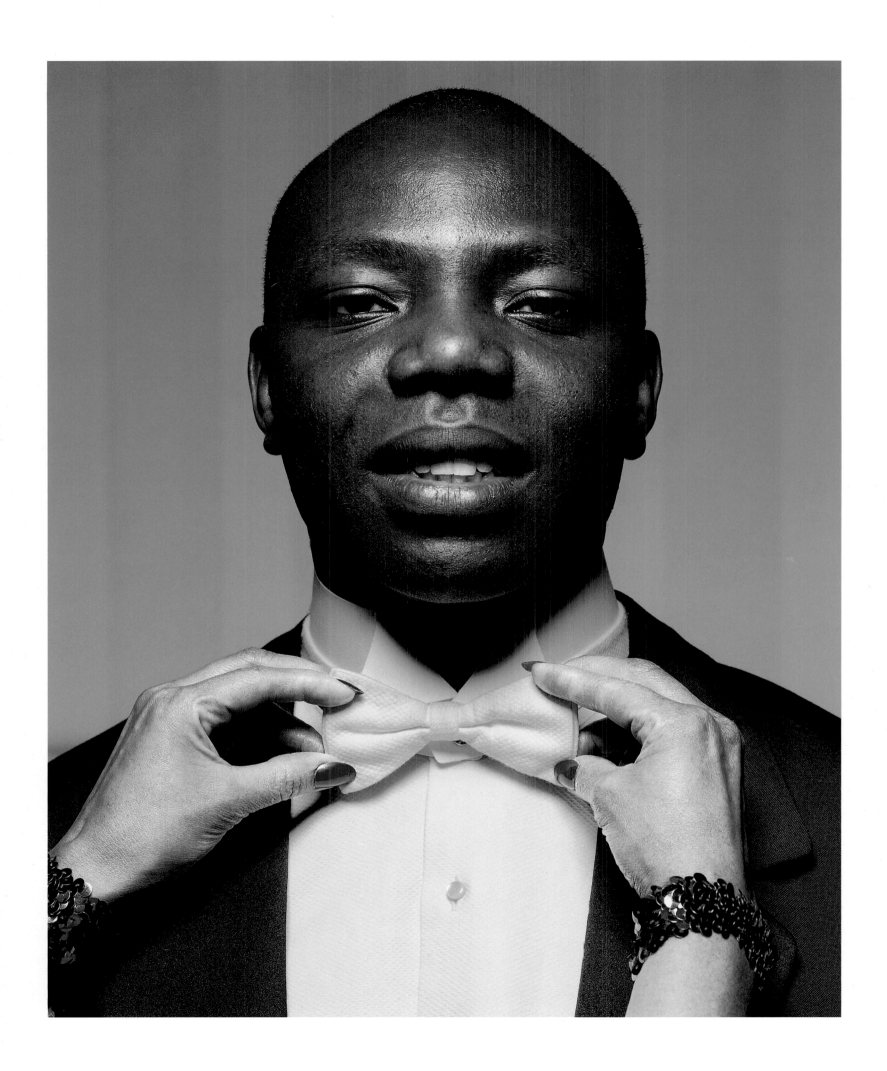

LIONEL FELIX
2ND. SENIOR BALLROOM DANCING, DANCE SPORT CHAMPIONSHIP
DOUBLE TREE HOTEL, TORONTO

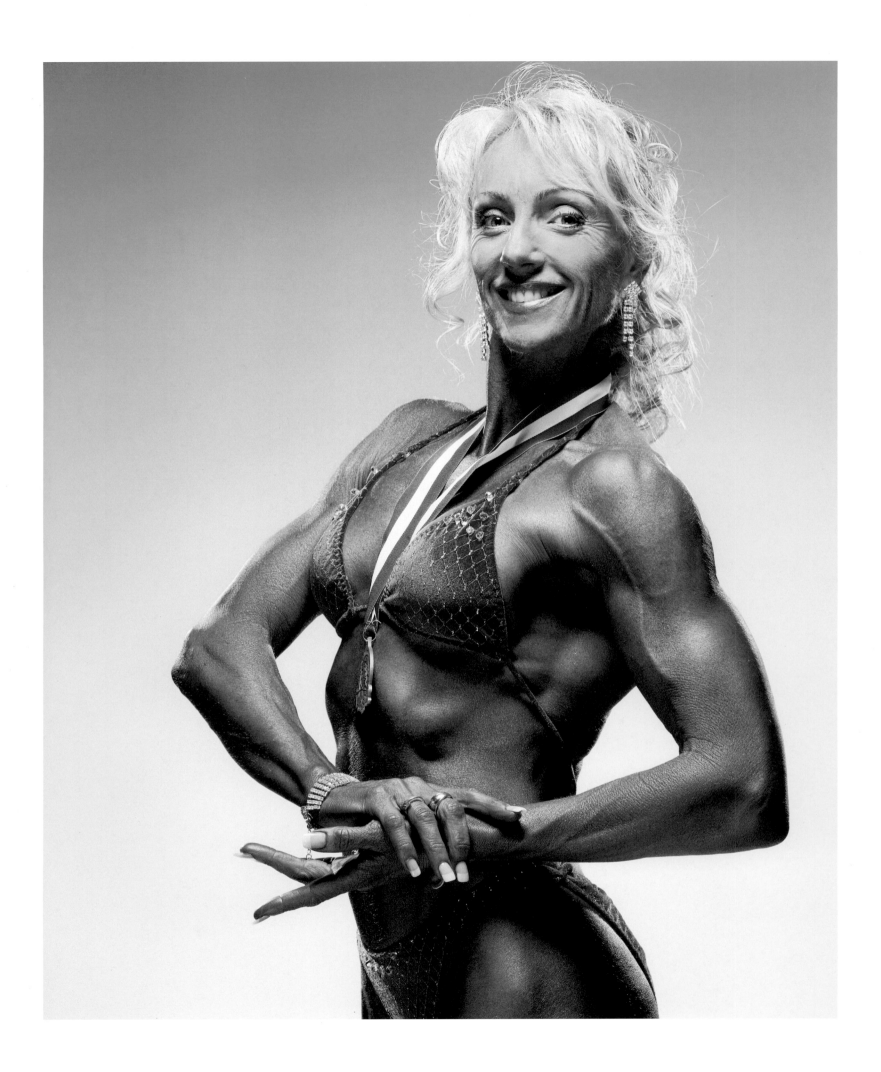

KAREN CROSSMAN
2ND, NATURAL BODY BUILDING, WORLD FAME CHAMPIONSHIP
AIRPORT CONVENTION CENTRE, TORONTO

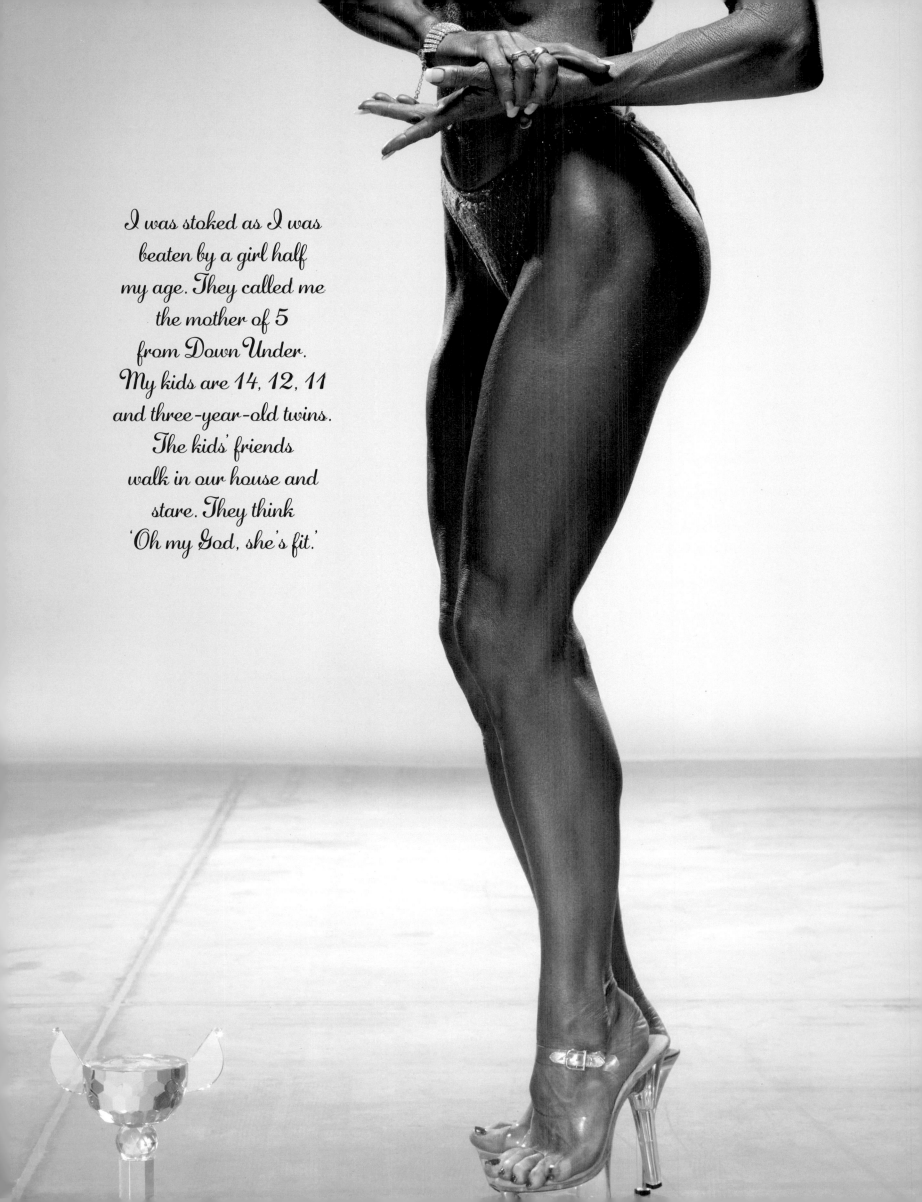

I was stoked as I was beaten by a girl half my age. They called me the mother of 5 from Down Under. My kids are 14, 12, 11 and three-year-old twins. The kids' friends walk in our house and stare. They think 'Oh my God, she's fit.'

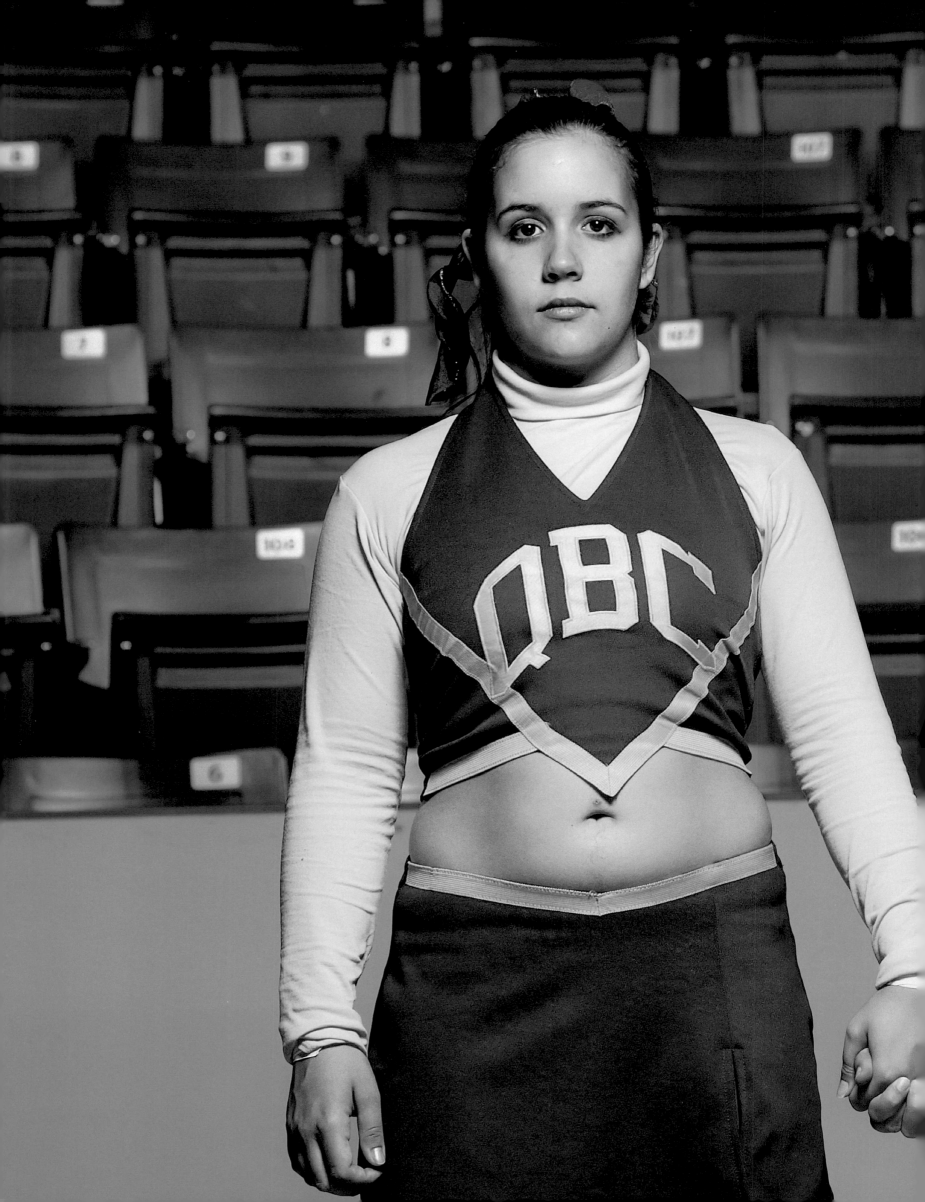

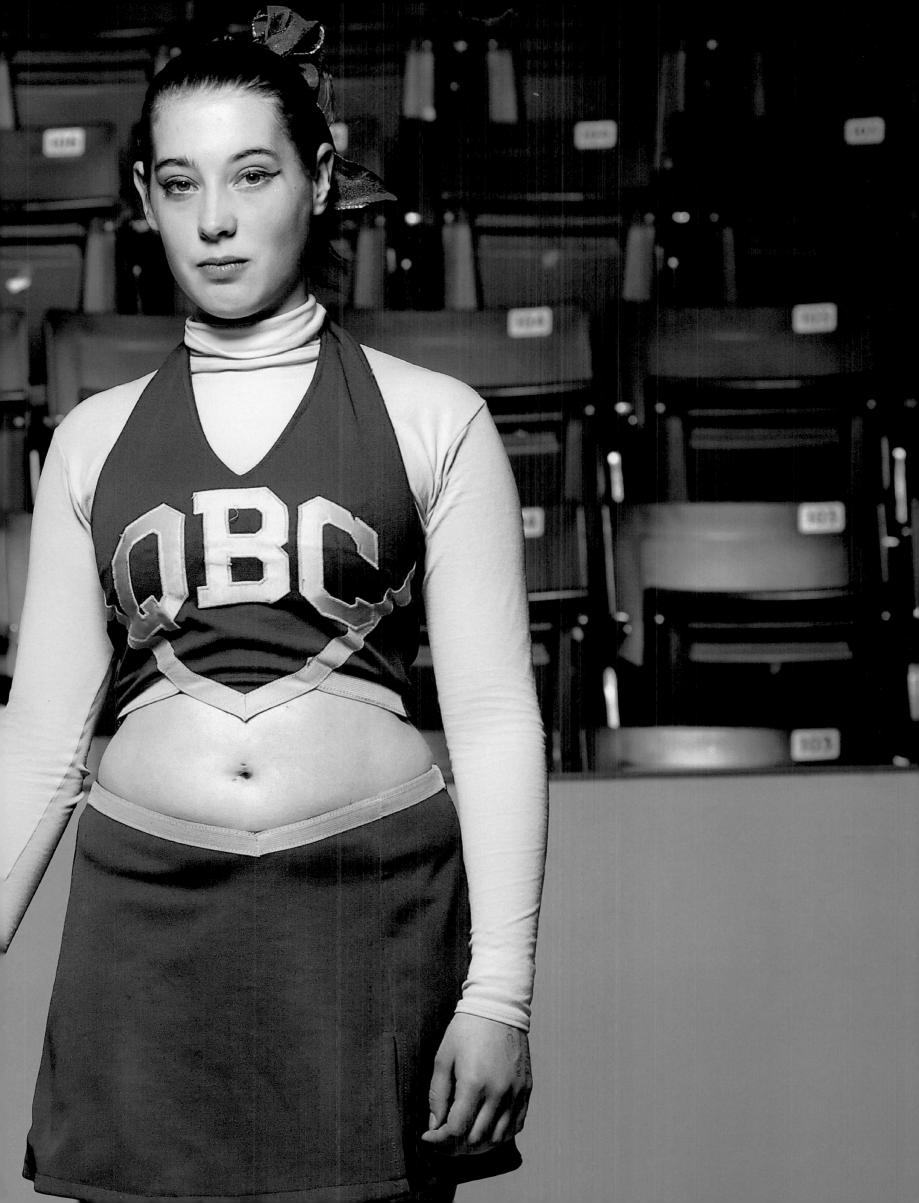

We are thinking we will quit the team.

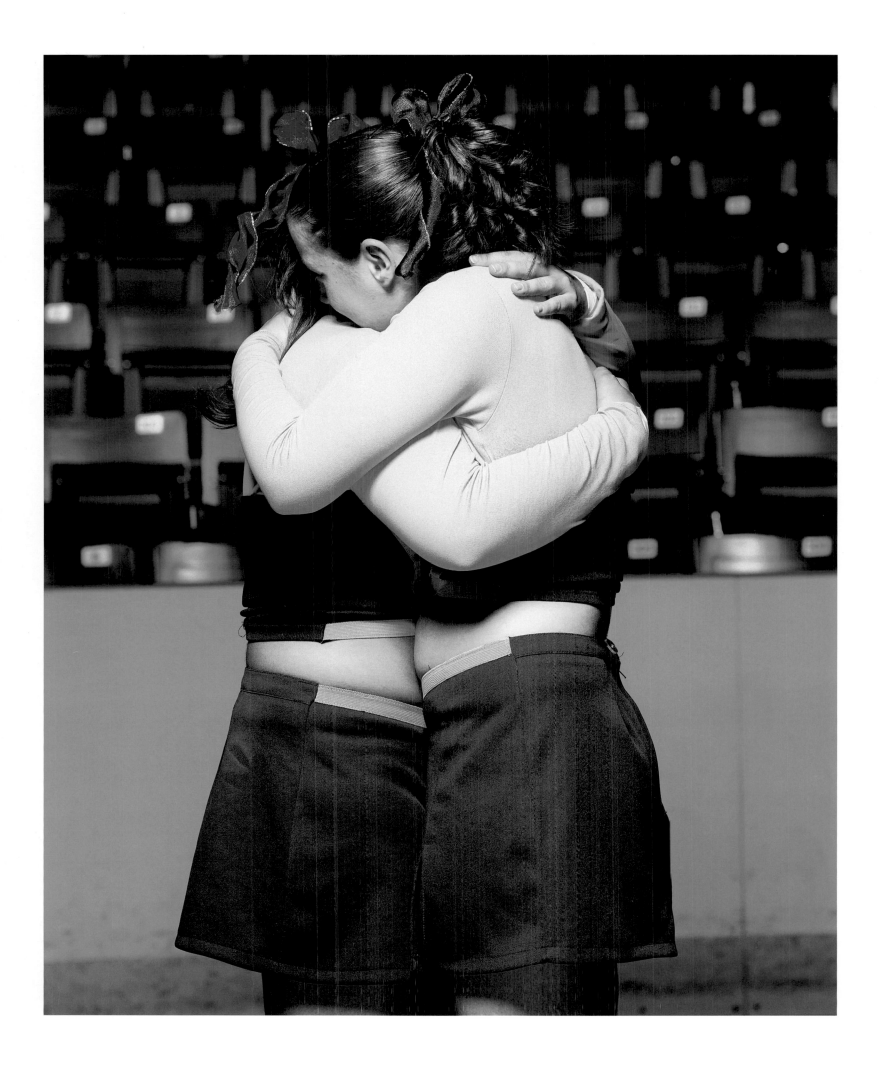

EMMA DONOVAN & ALI PETERSON, QUINTE BAY CHEERLEADING JAGUARS
2ND, POWER CHEER NATIONALS
HERSHEY ARENA, MISSISSAUGA, ONTARIO

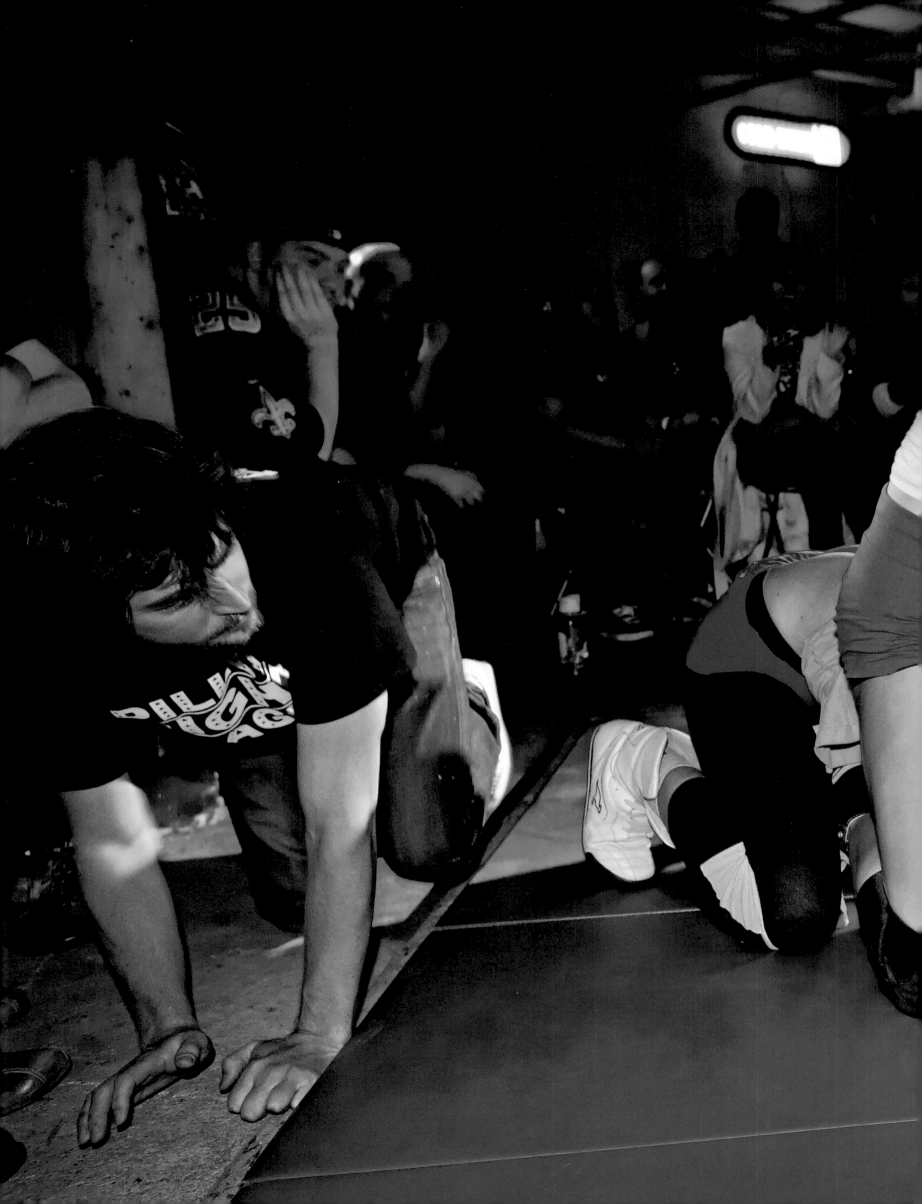

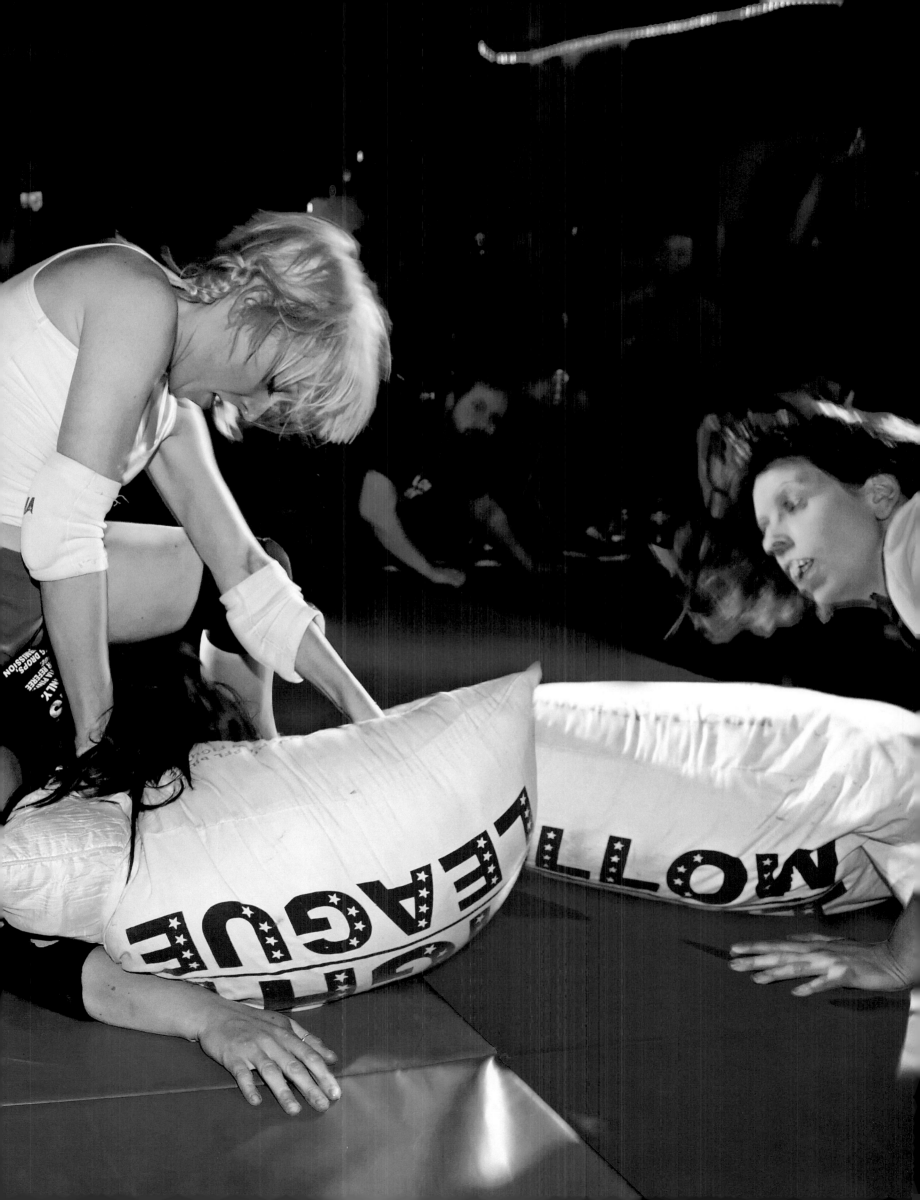

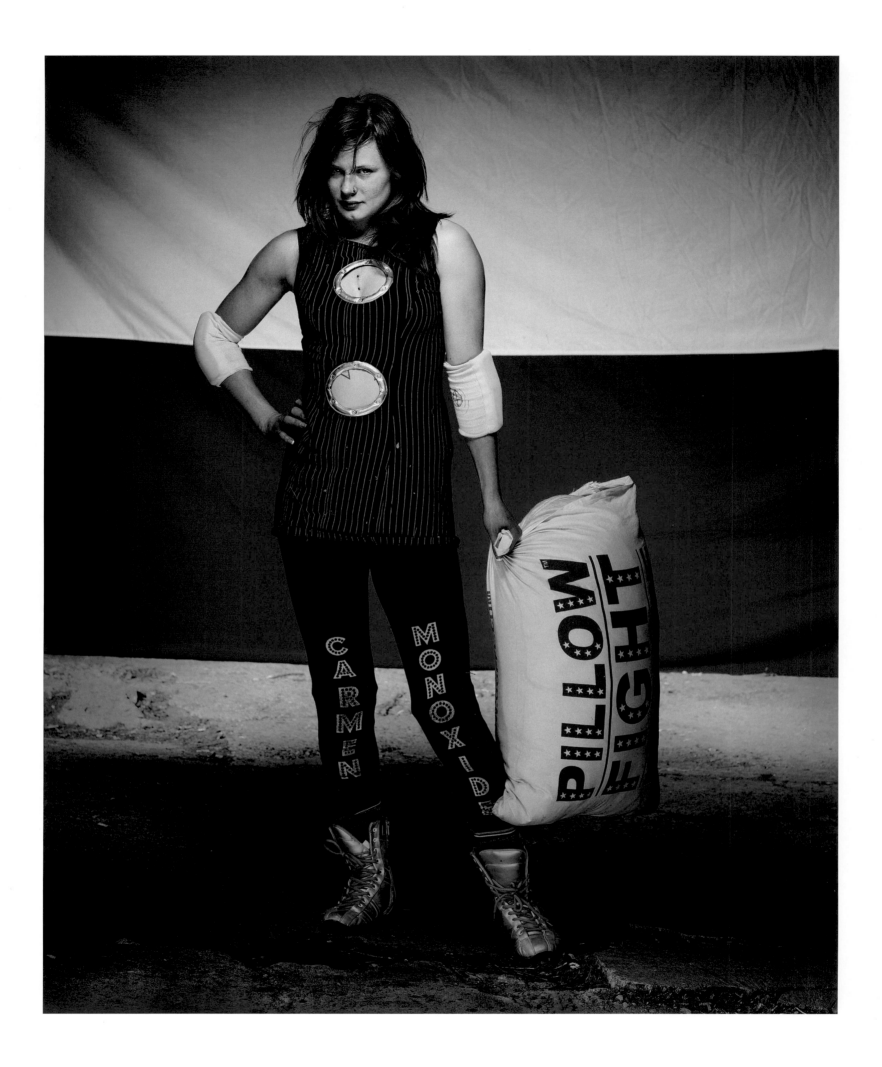

CARMEN MONOXIDE
2ND, THE PILLOW FIGHT LEAGUE
GLADSTONE HOTEL, TORONTO

I was hoping to try and choke
her with the pillow and make her pass out.
I knew I couldn't hold her down.
I felt when we were fighting that she was
kicking my ass. It went to
judges, and when she won, I was mad,
really mad, so I attacked her.
I have bruises all over my legs and arms.

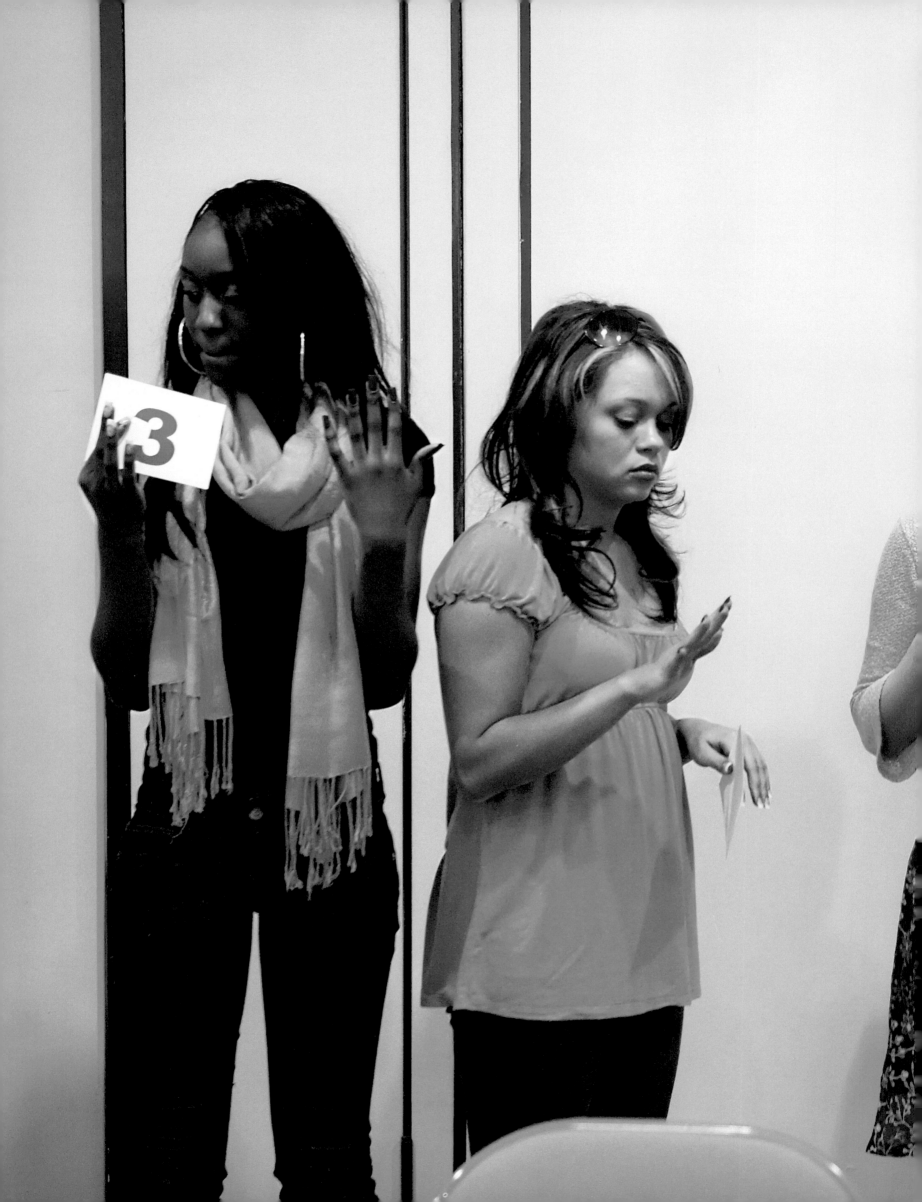

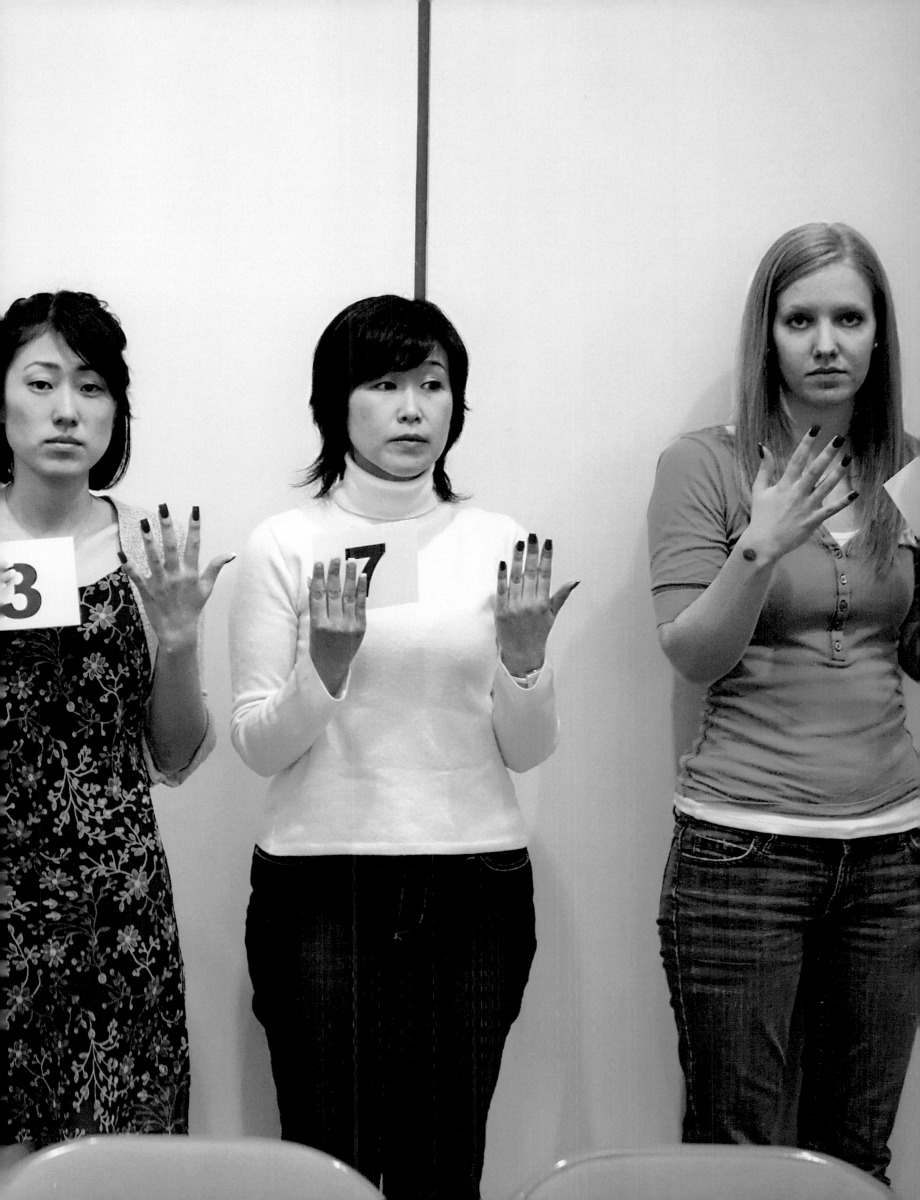

I've just been told I should have won.
The judges don't know what
they are doing. It's been a 13-hour day
and I just want to go home.

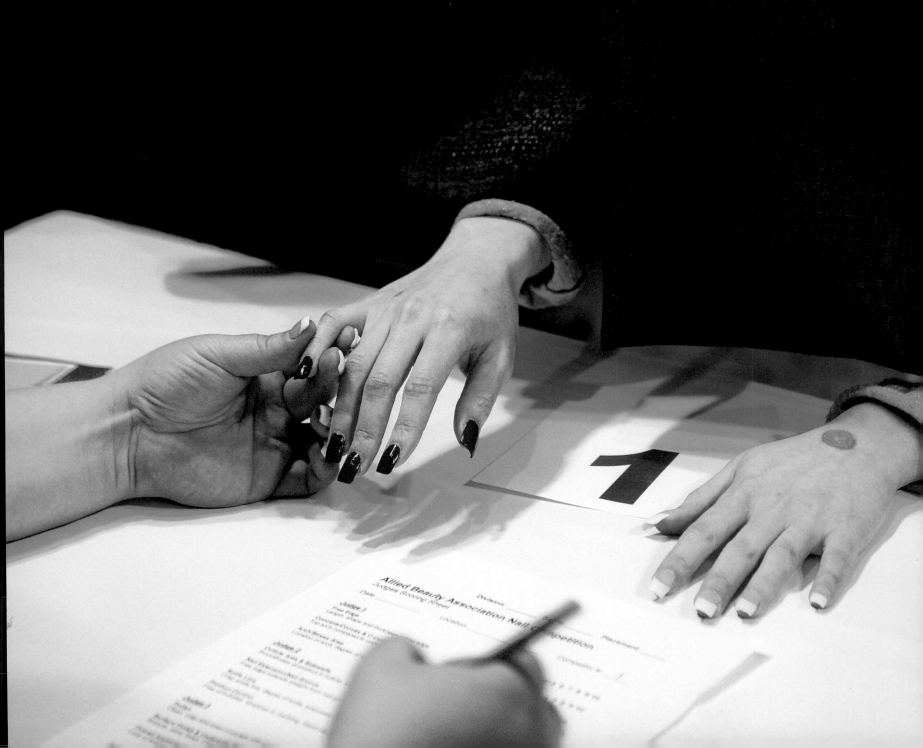

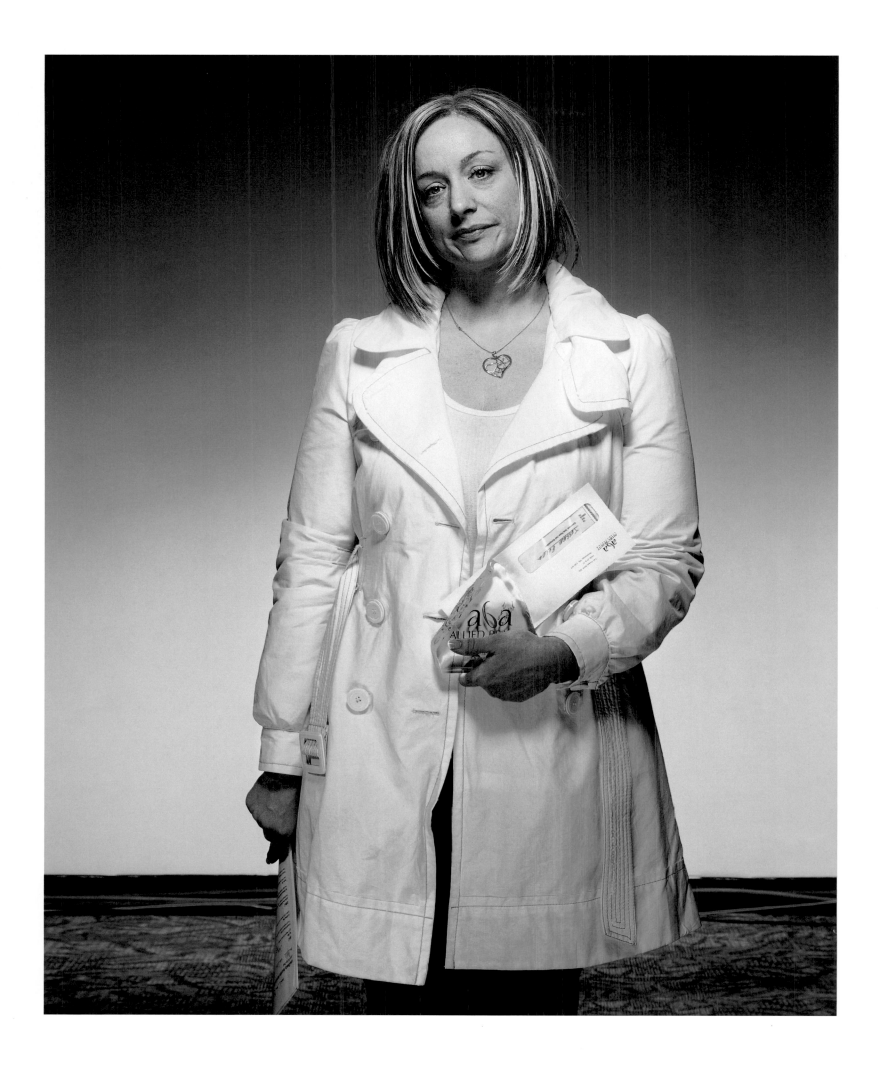

JESSICA ELLISON
2ND, SALON STYLE NAILS, ALLIED BEAUTY ASSOCIATION NAIL COMPETITION
METRO TORONTO CONVENTION CENTRE, TORONTO

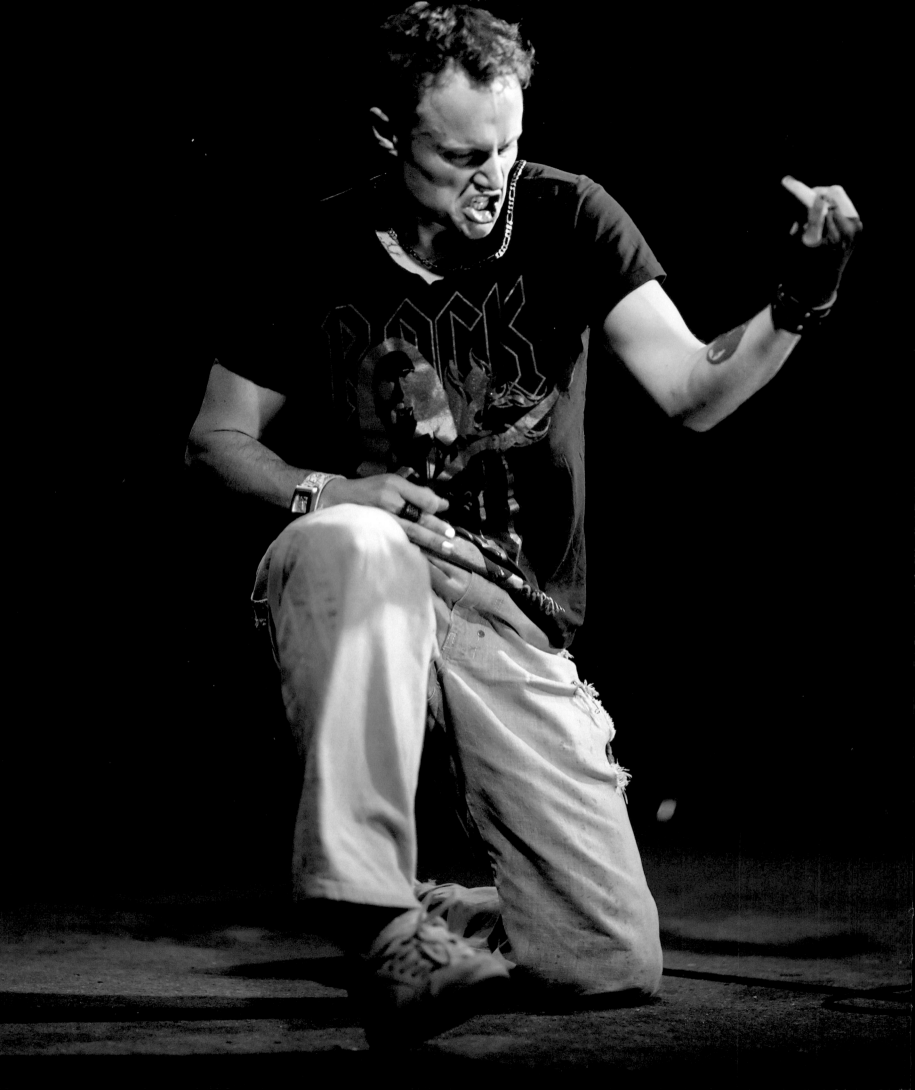

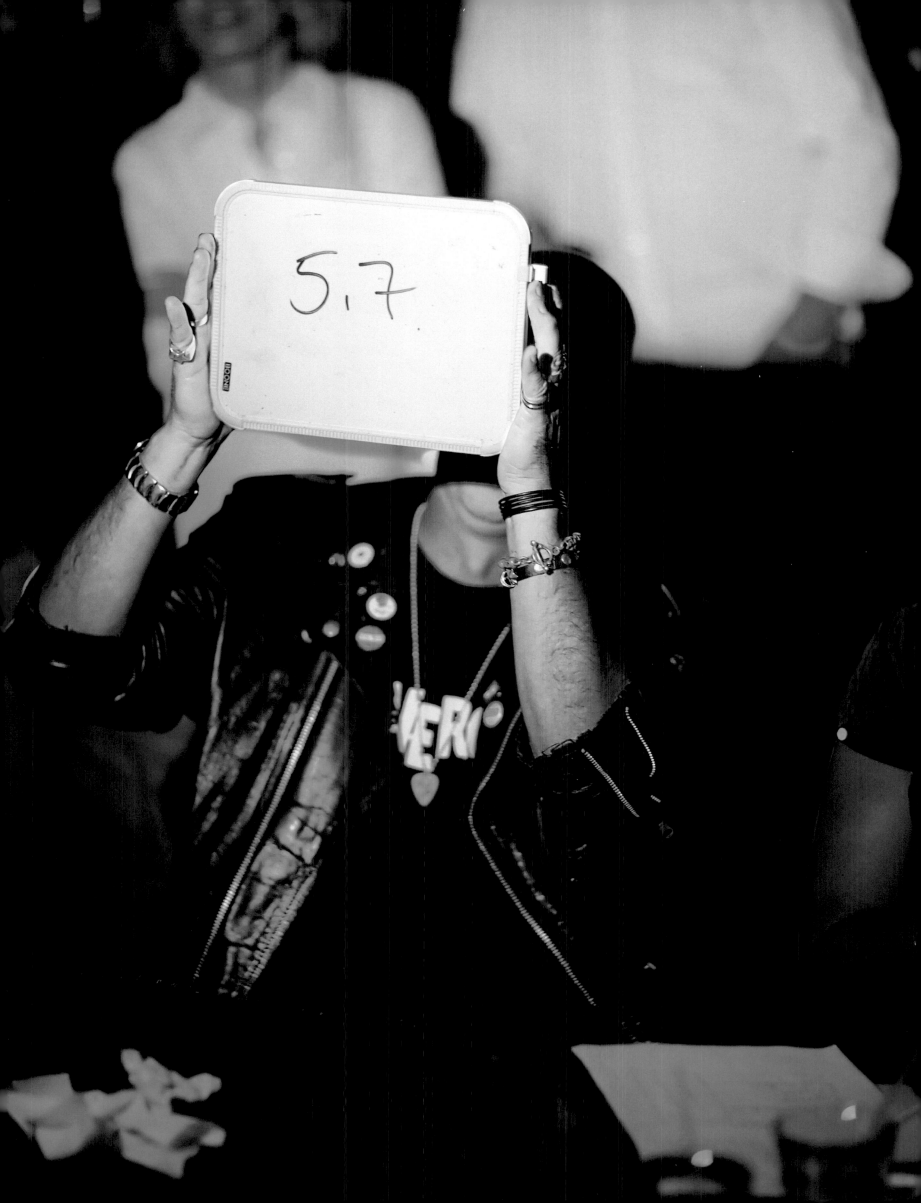

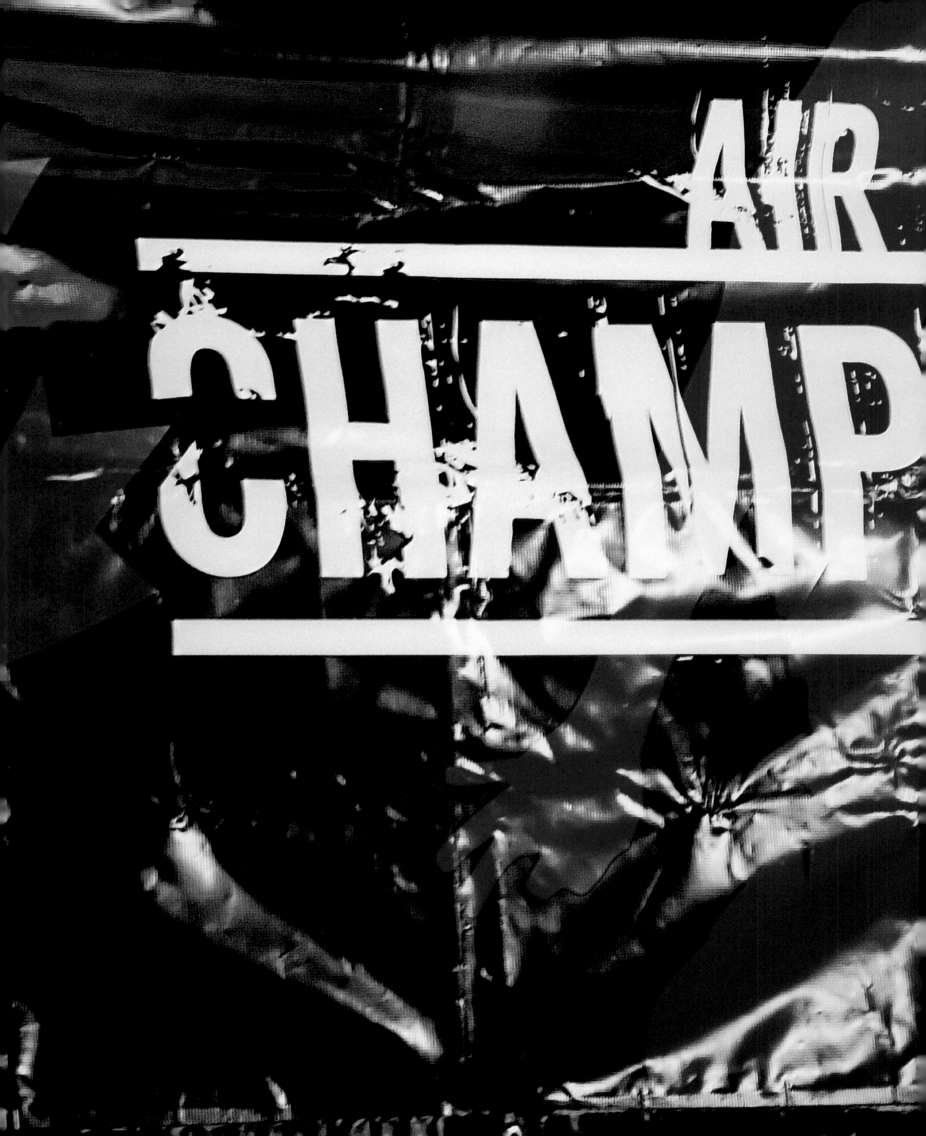

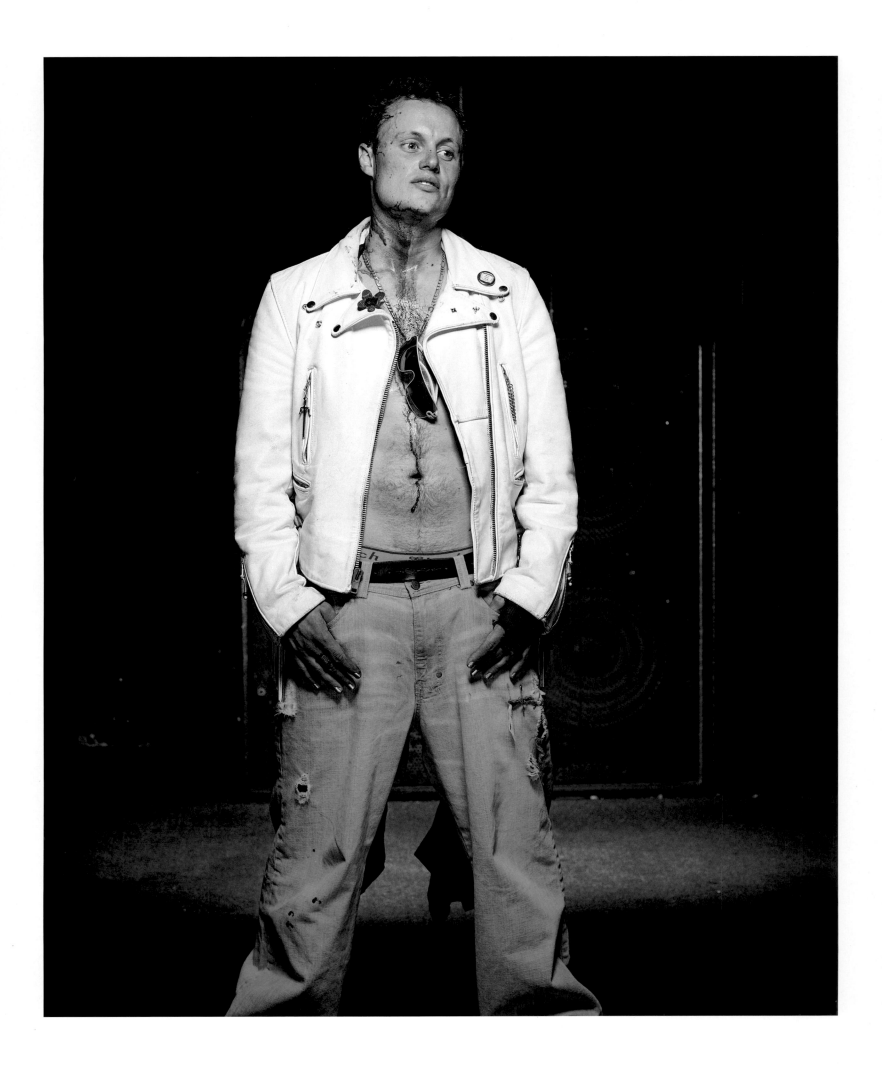

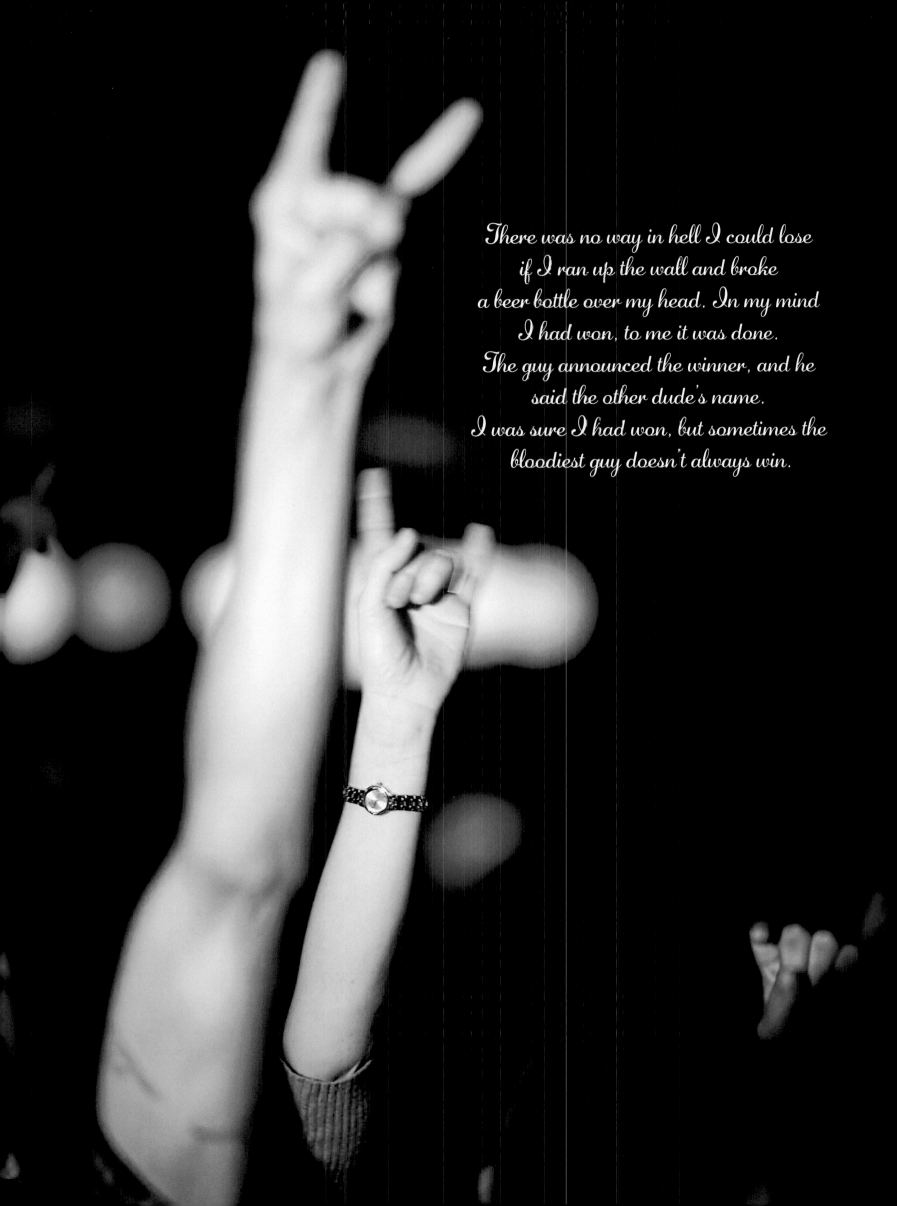

There was no way in hell I could lose
if I ran up the wall and broke
a beer bottle over my head. In my mind
I had won, to me it was done.
The guy announced the winner, and he
said the other dude's name.
I was sure I had won, but sometimes the
bloodiest guy doesn't always win.

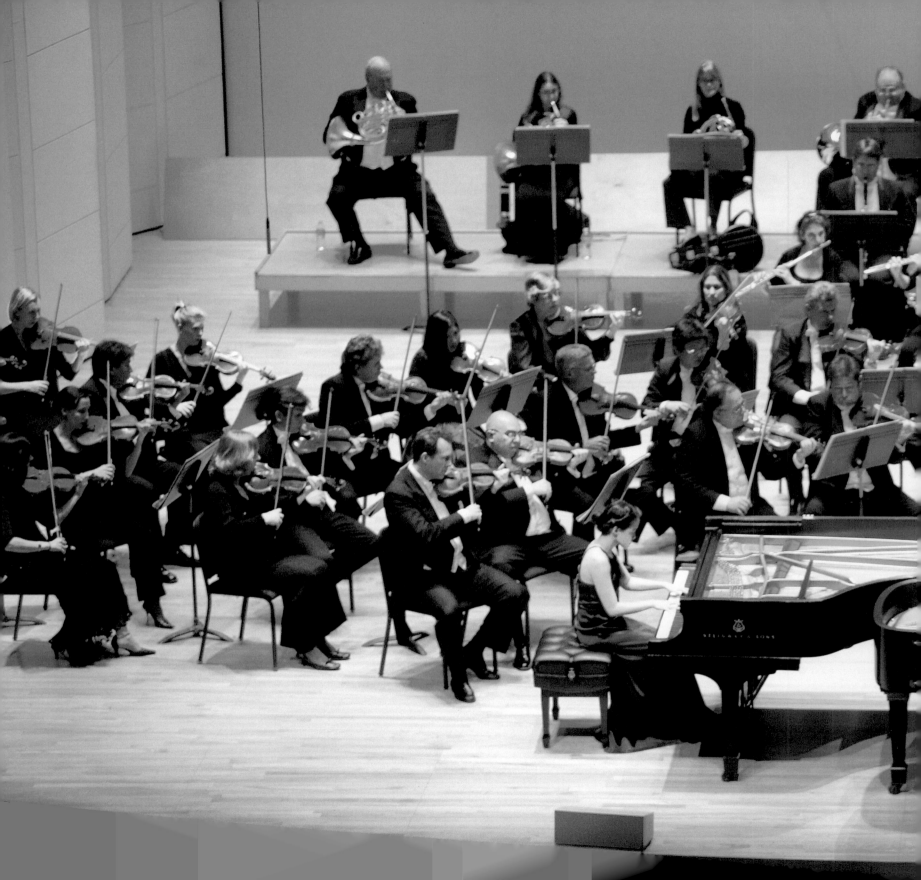

When I heard 3rd Place being
announced, I was happy it was not us—
it was as I expected. We were
in the wings behind a screen. My heart was
pounding like crazy, my arms were
all tingly. I heard my name and the next thing
I knew, we were onstage and 2nd.
We were a little disappointed, but you have
to smile and be nice.

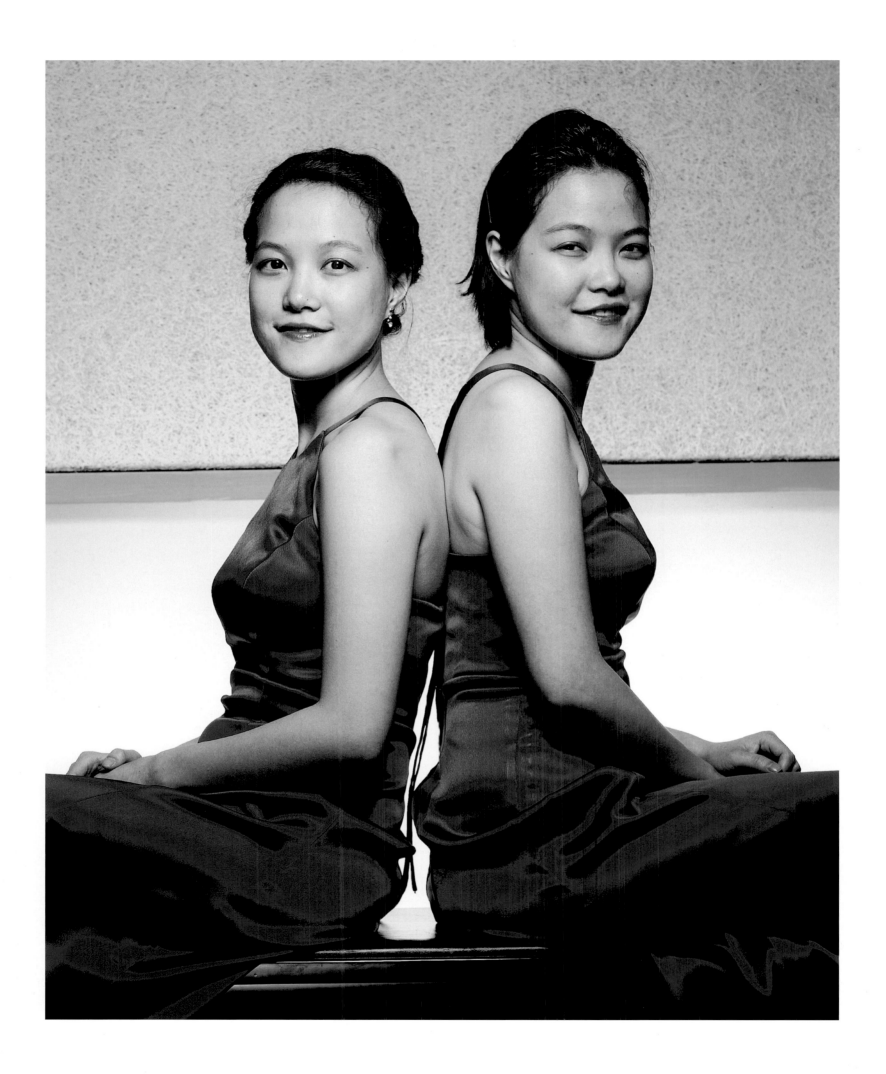

SARAH WANG & SUSAN WANG

2ND, TWO PIANO PERFORMANCE, DRANOFF INTERNATIONAL TWO PIANO COMPETITION

LINCOLN THEATER, MIAMI

It's not something I prefer to discuss,
but I knew I had lost before the final throw.

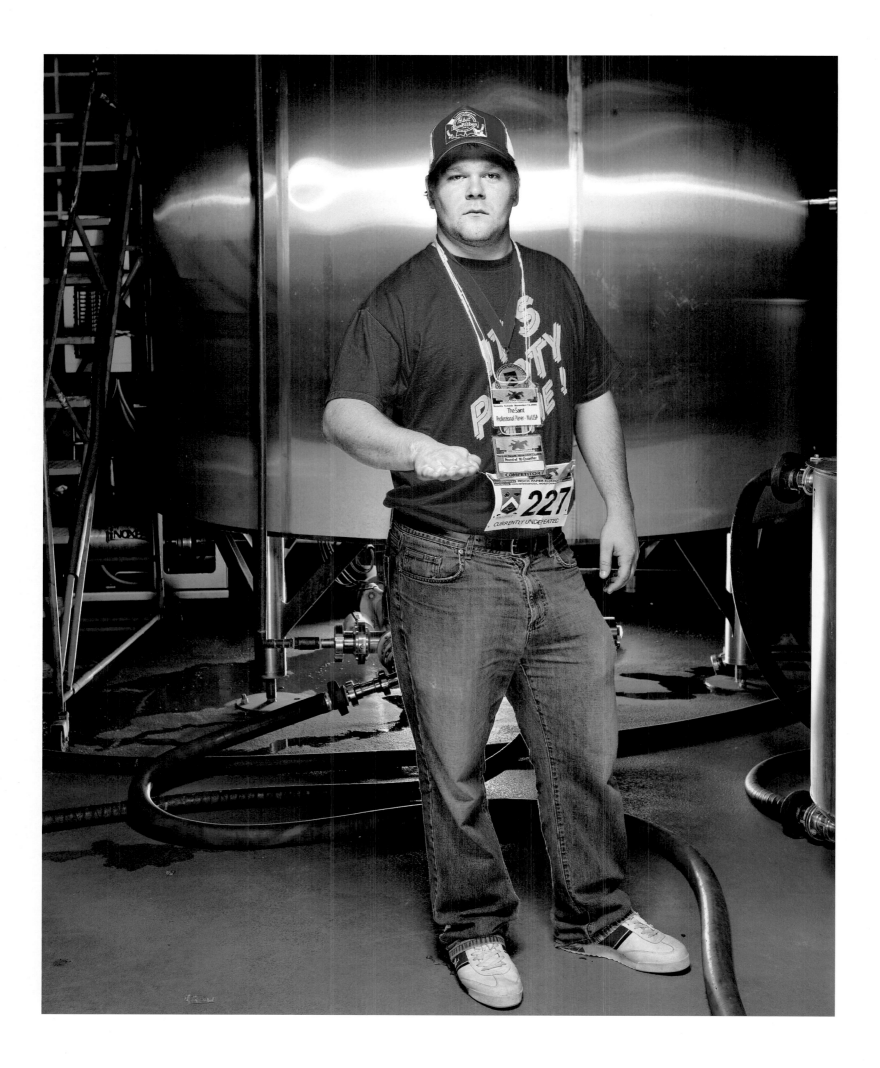

BRYAN BENNETT
2ND, ROCK PAPER SCISSORS WORLD SERIES
STEAM WHISTLE BREWERY, TORONTO

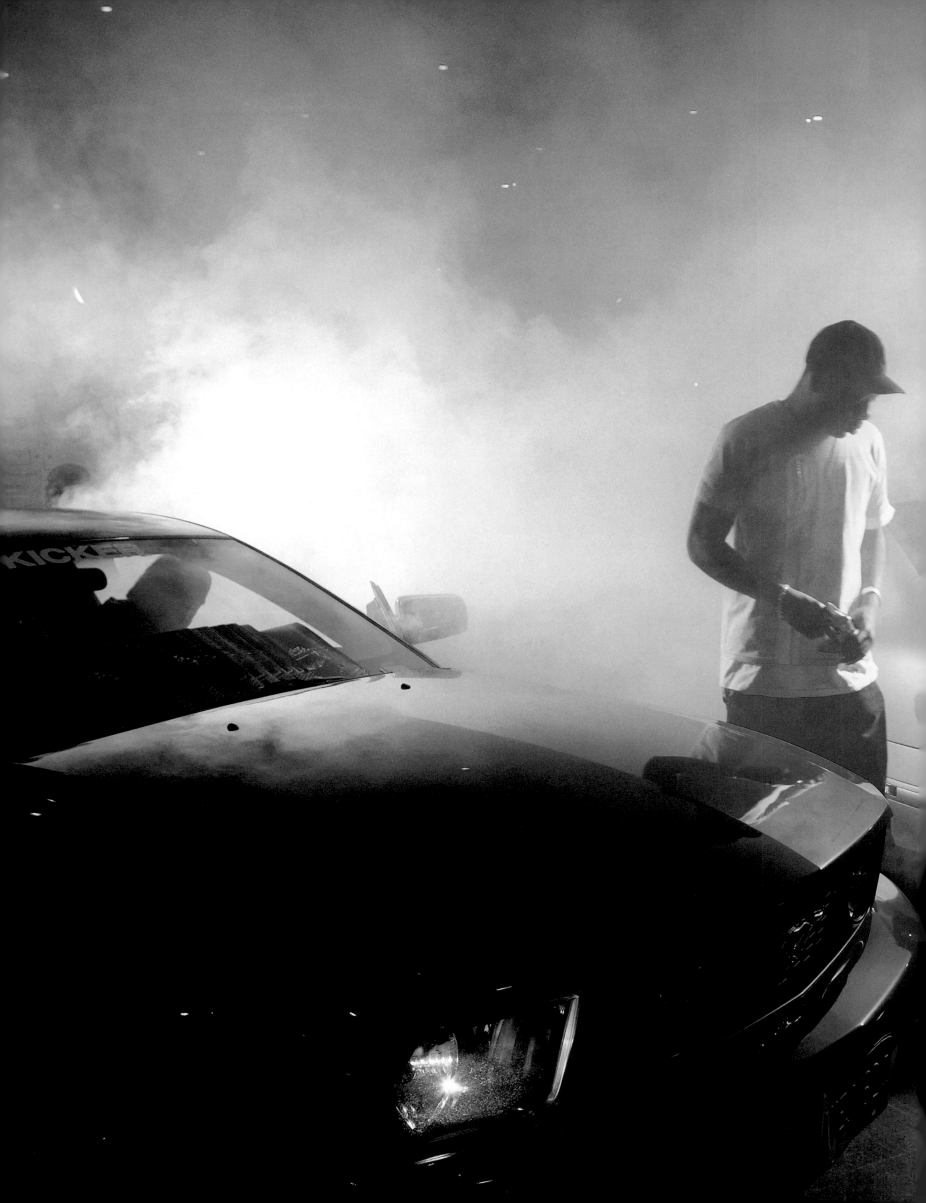

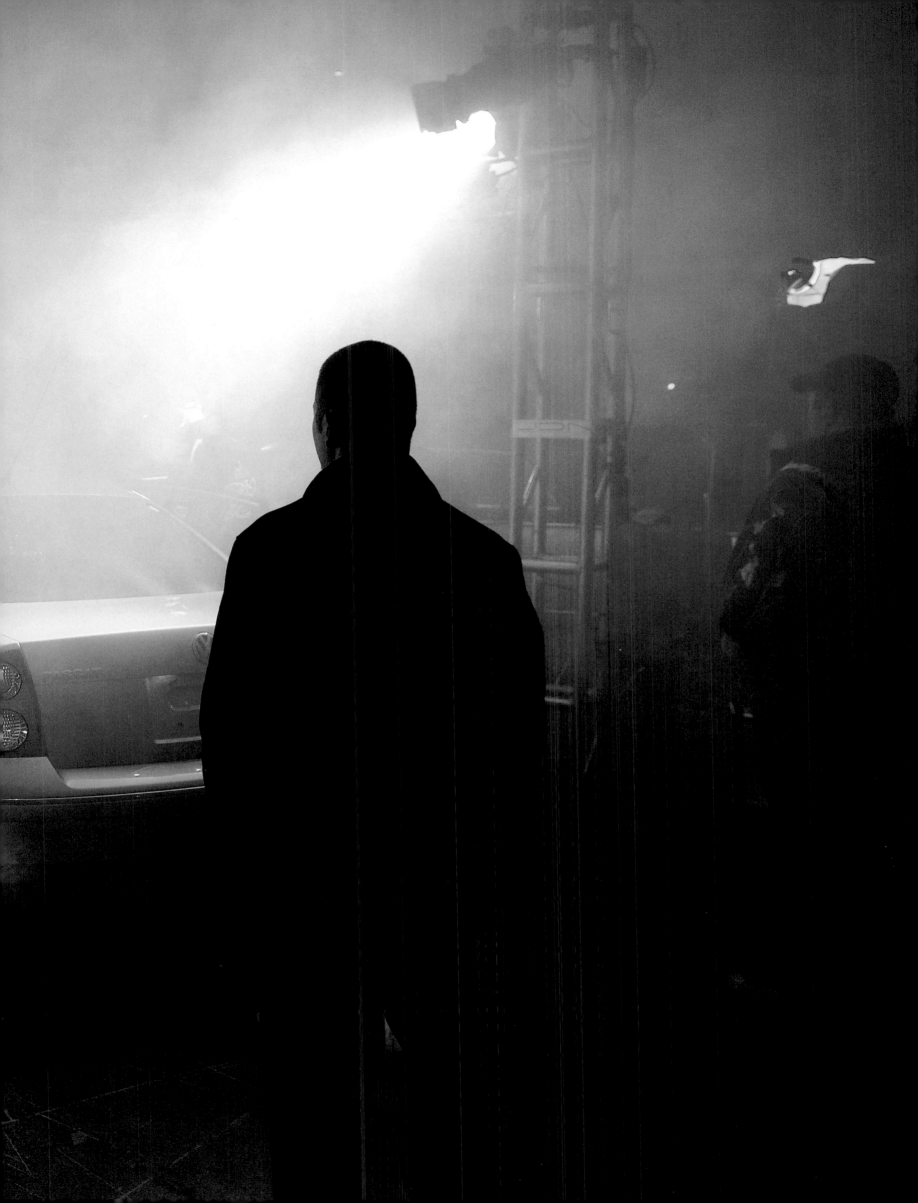

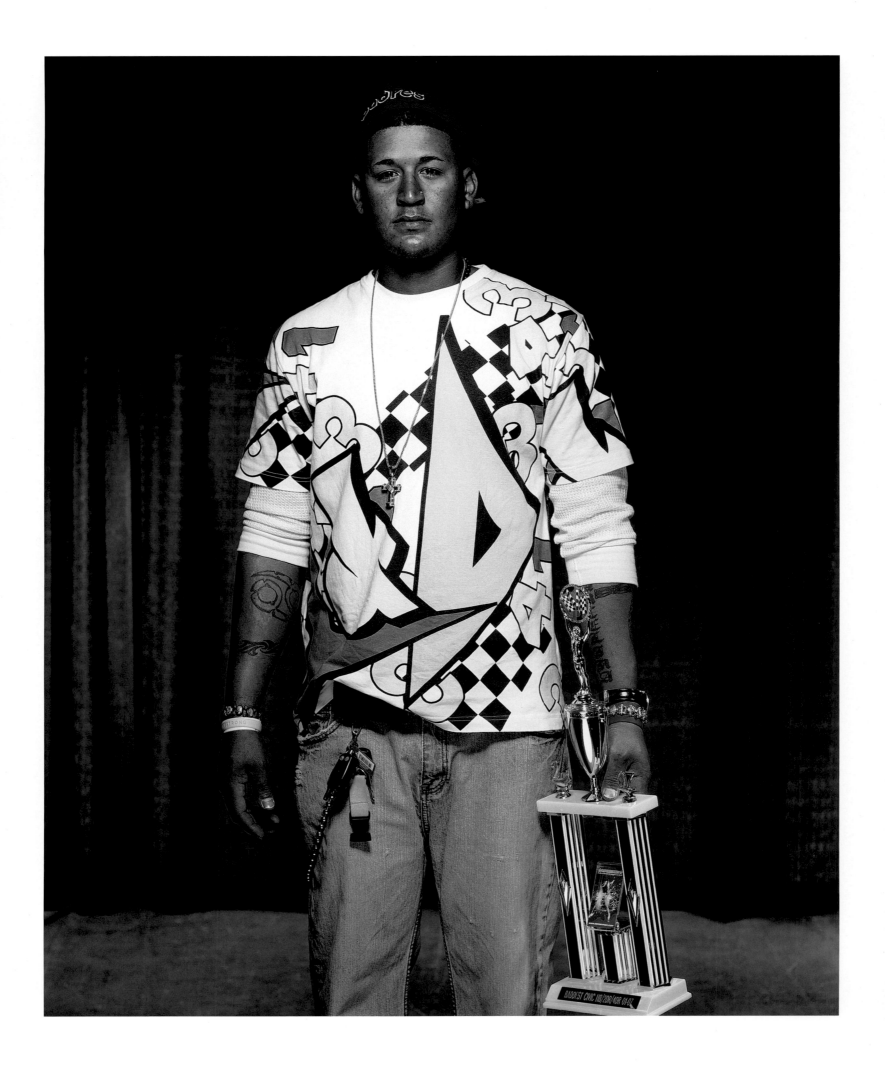

**FREDDIE RIVERA**
2ND, BADDEST HONDA CIVIC, IMPORT FEST CAR SHOW
METRO TORONTO CONVENTION CENTRE, TORONTO

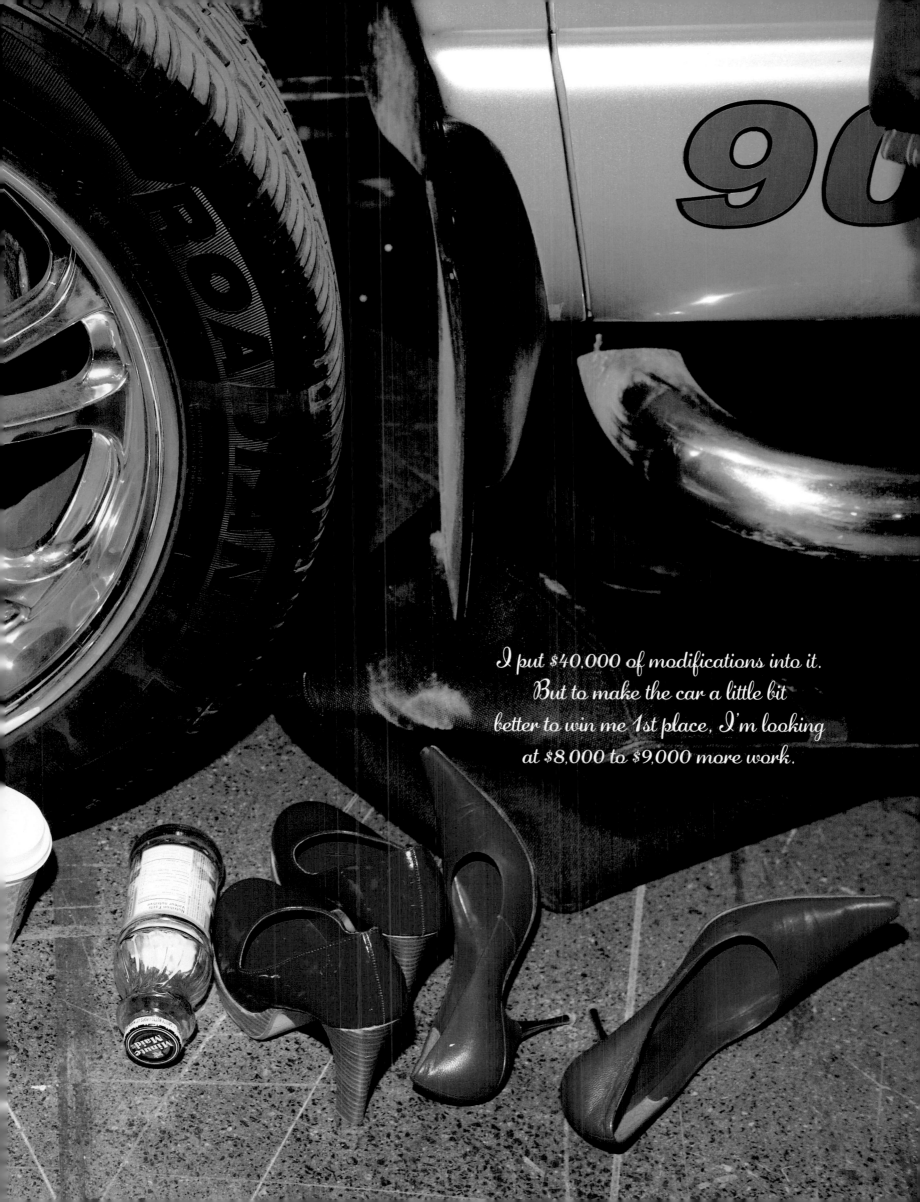

*I put $40,000 of modifications into it. But to make the car a little bit better to win me 1st place, I'm looking at $8,000 to $9,000 more work.*

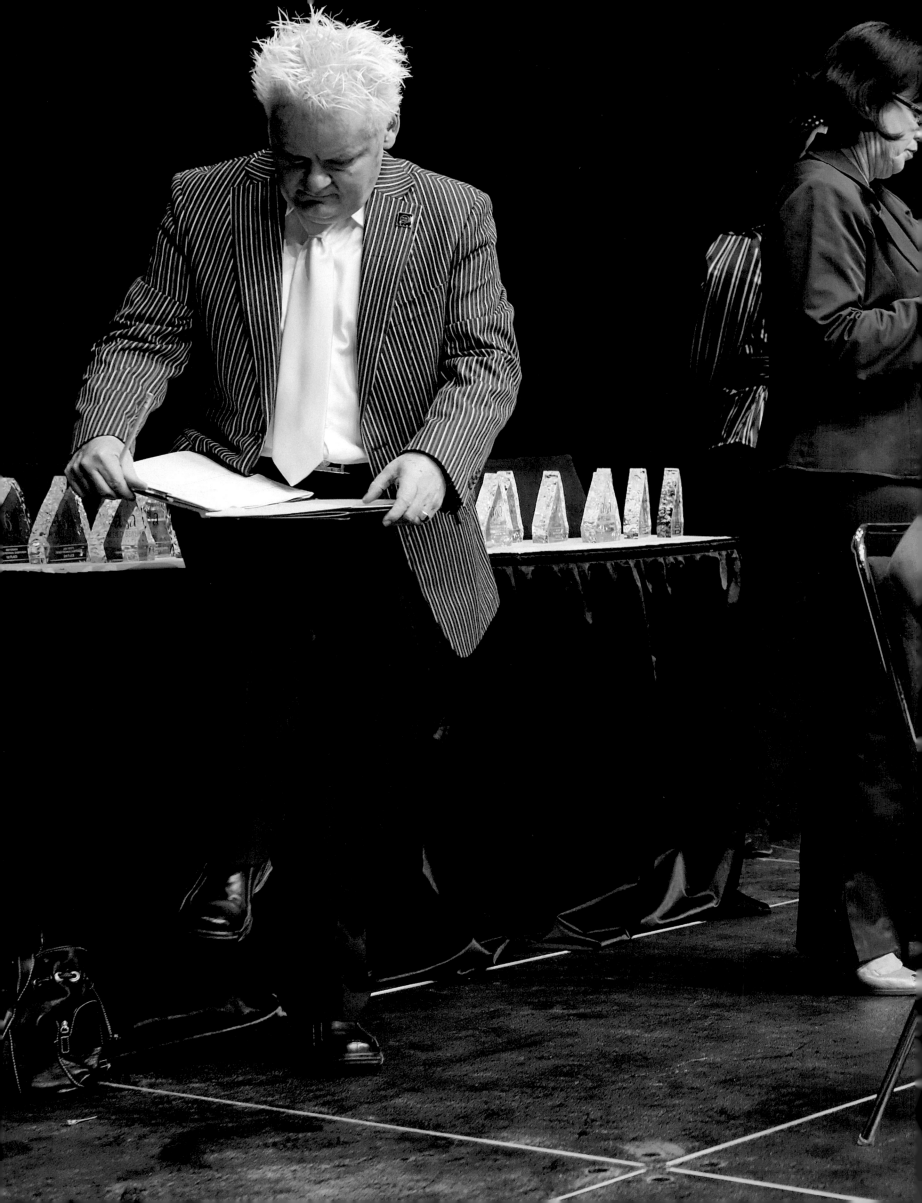

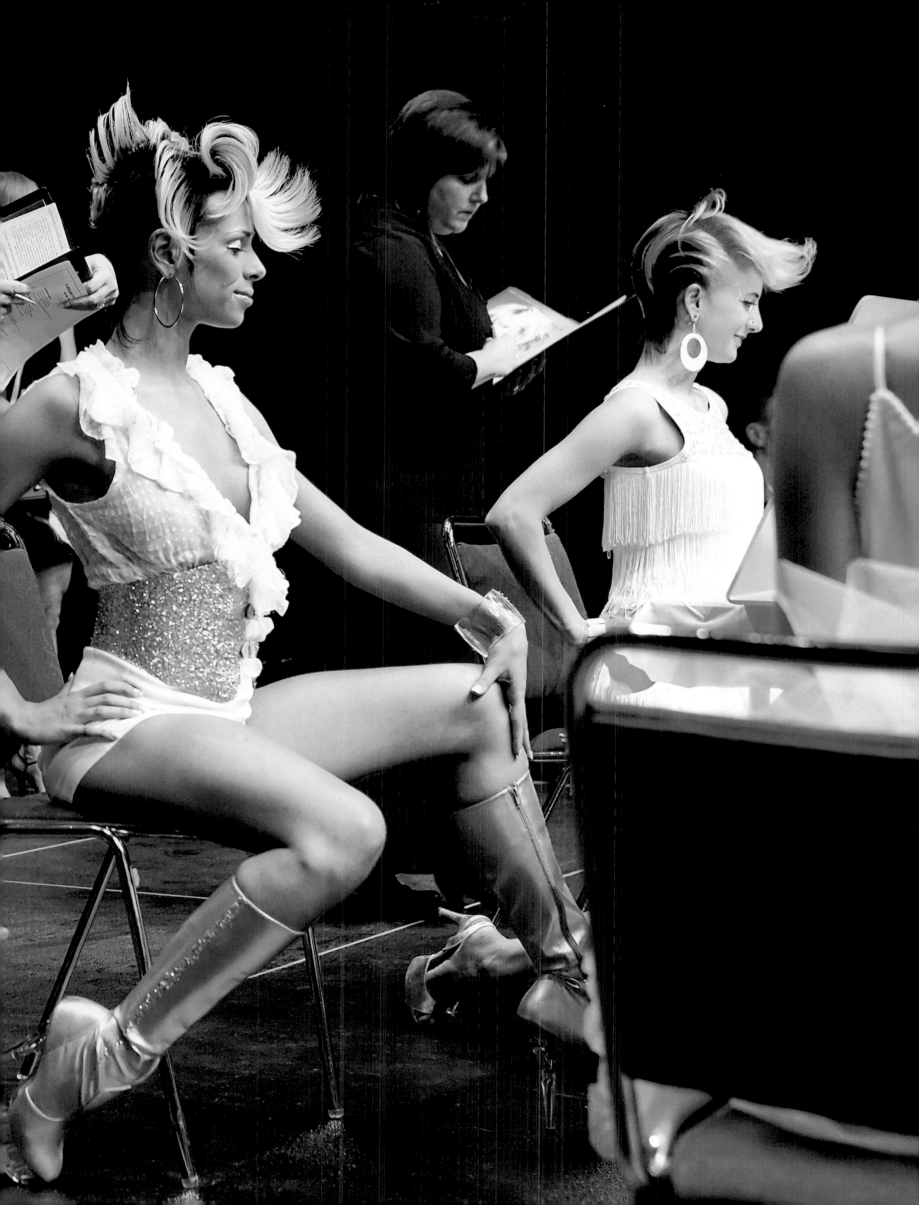

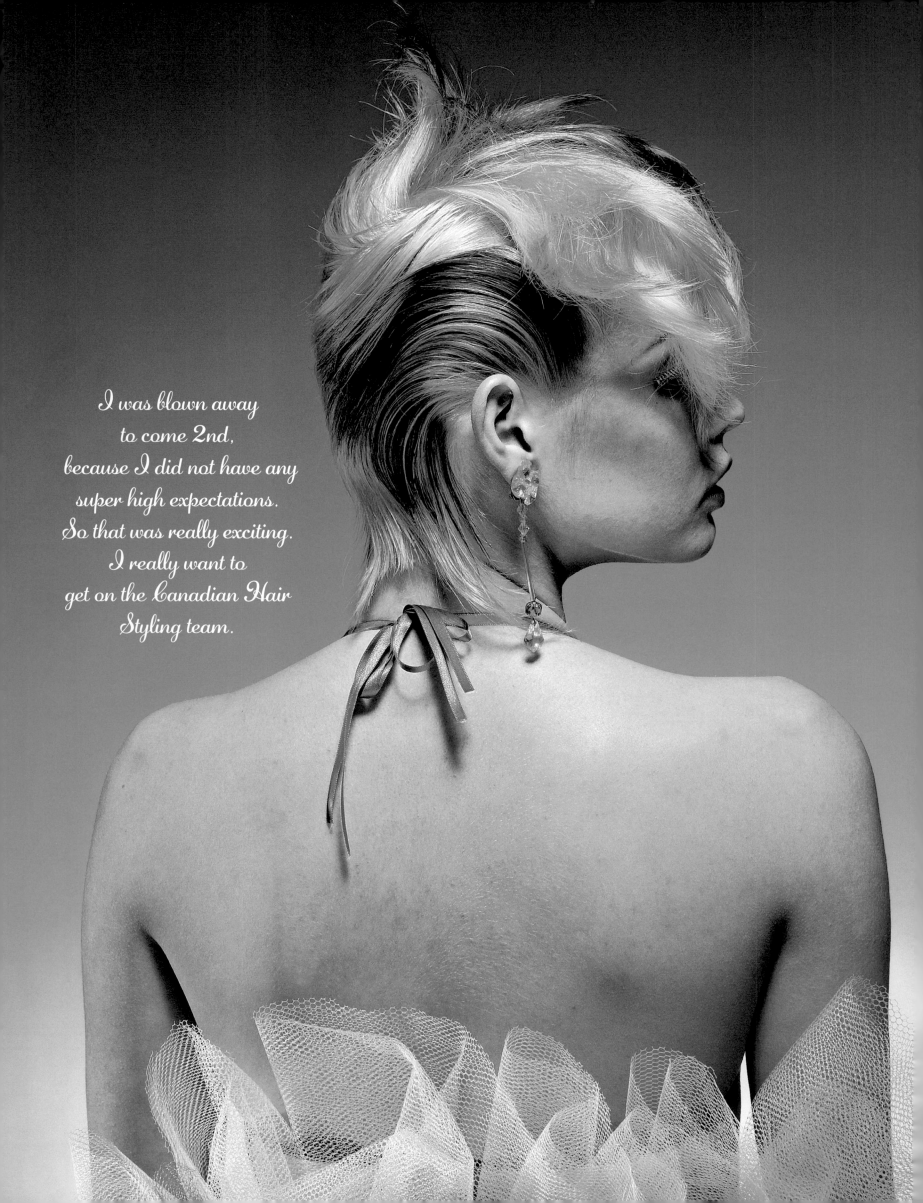

*I was blown away
to come 2nd,
because I did not have any
super high expectations.
So that was really exciting.
I really want to
get on the Canadian Hair
Styling team.*

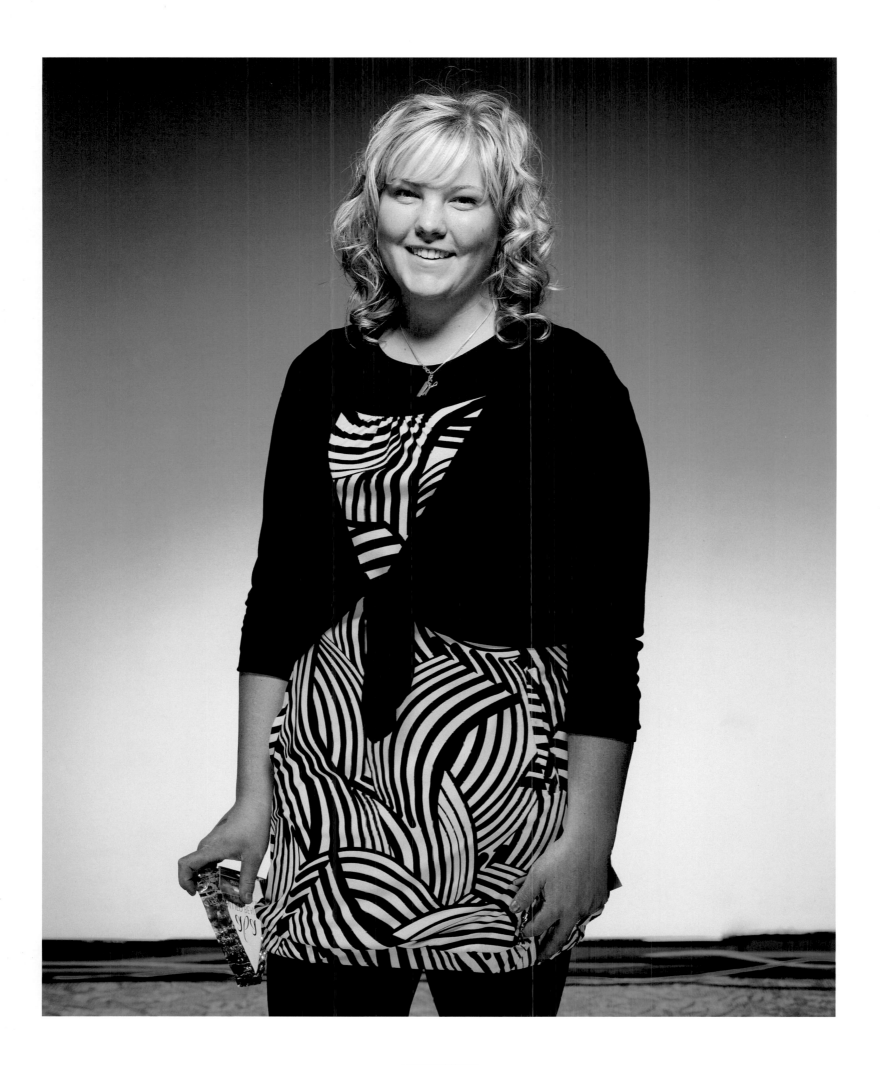

ALLISON MCKEE
2ND, TECHNICAL CREATIVE DAY STYLE, ONTARIO PROVINCIAL CHAMPIONSHIP, ALLIED BEAUTY HAIR EVENT
METRO TORONTO CONVENTION CENTRE, TORONTO

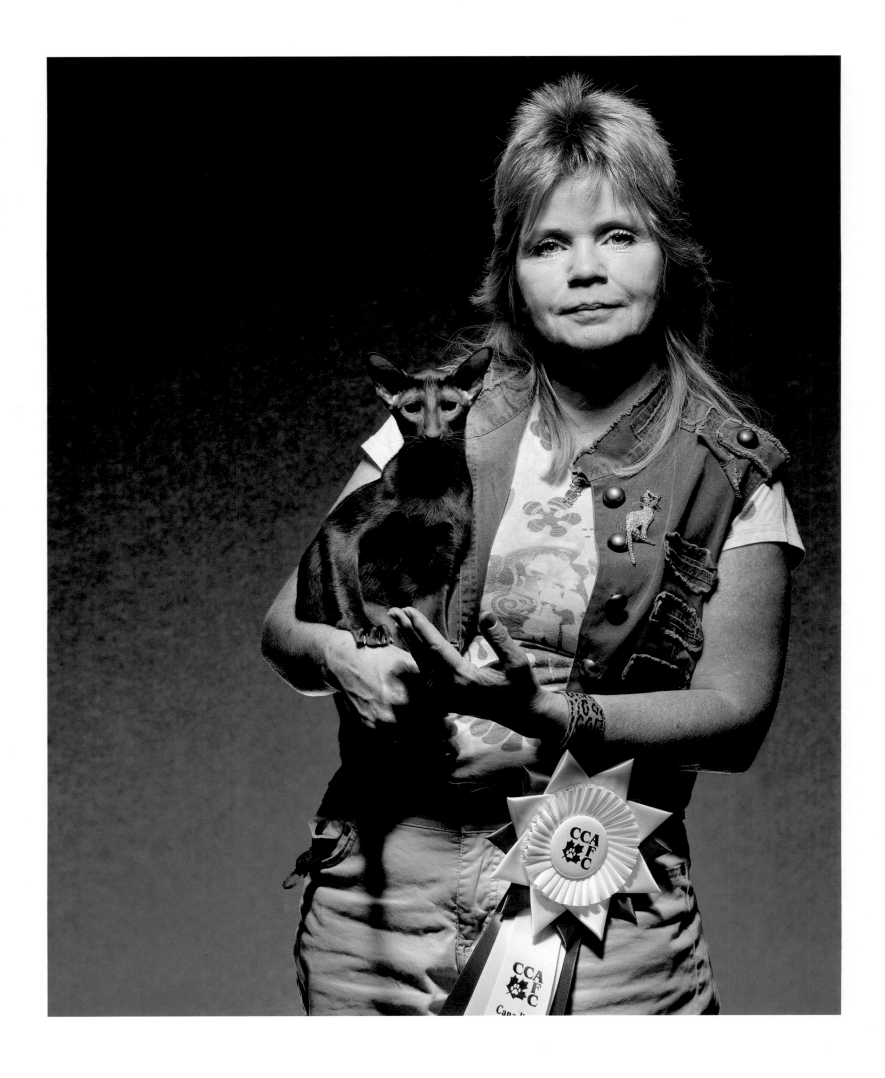

LINDA RUSSELL & NUTMEG SUGAR
2ND, SHORT HAIR SPECIALTY, KITTEN, CANADIAN CAT ASSOCIATION
EXHIBITION PLACE, TORONTO

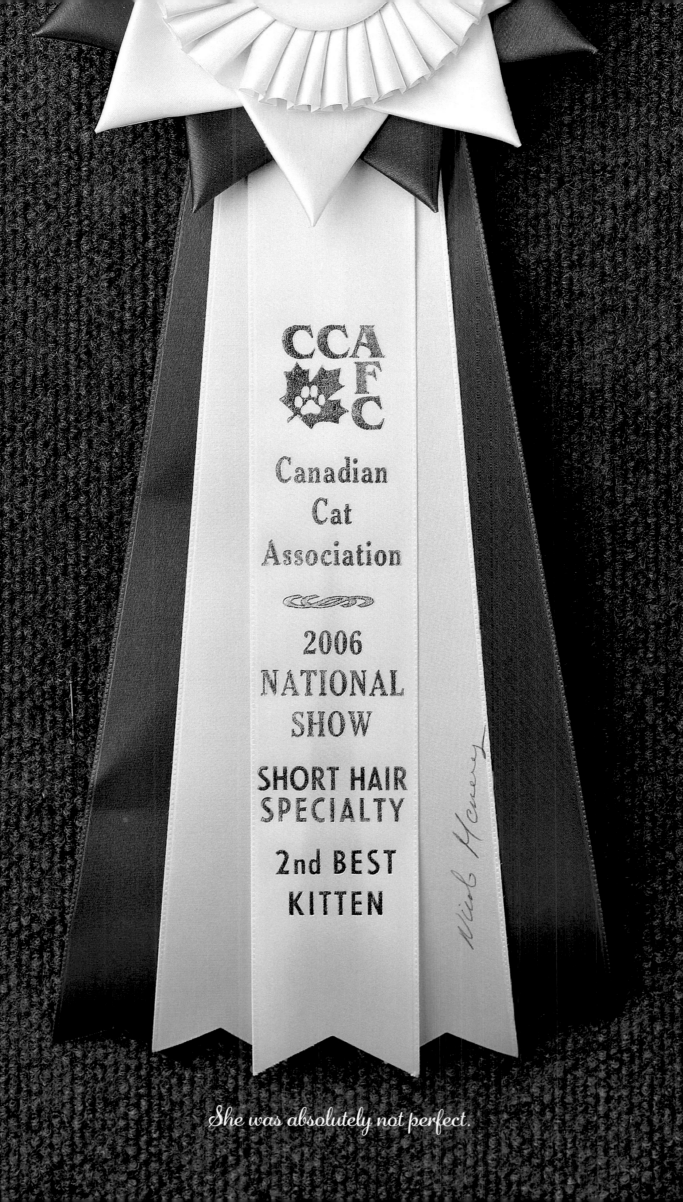

CCA F C

Canadian
Cat
Association

2006
NATIONAL
SHOW

SHORT HAIR
SPECIALTY

2nd BEST
KITTEN

*She was absolutely not perfect.*

It's quite a tough thing,
but when you lose you can't
get yourself down.

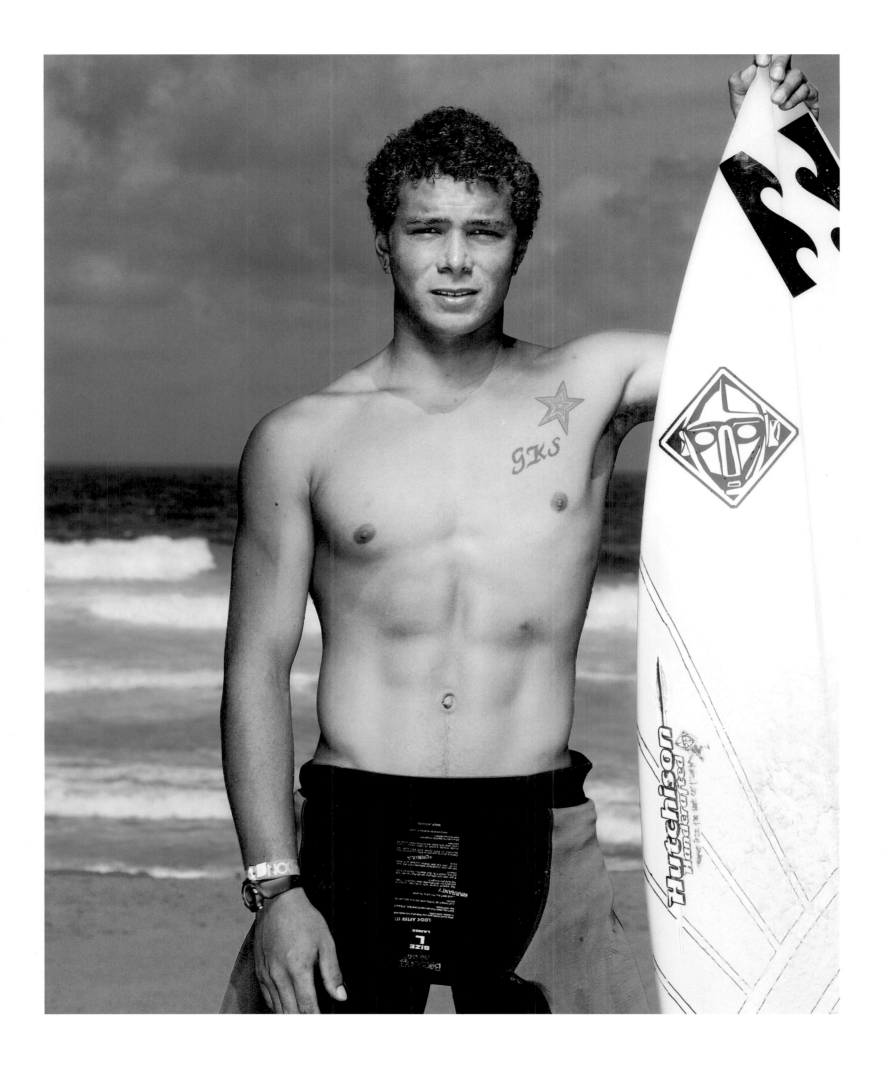

KLEE STRACHAN
2ND, SURFER, BILLABONG PRO JUNIOR
NORTH NARRABEEN BEACH, SYDNEY

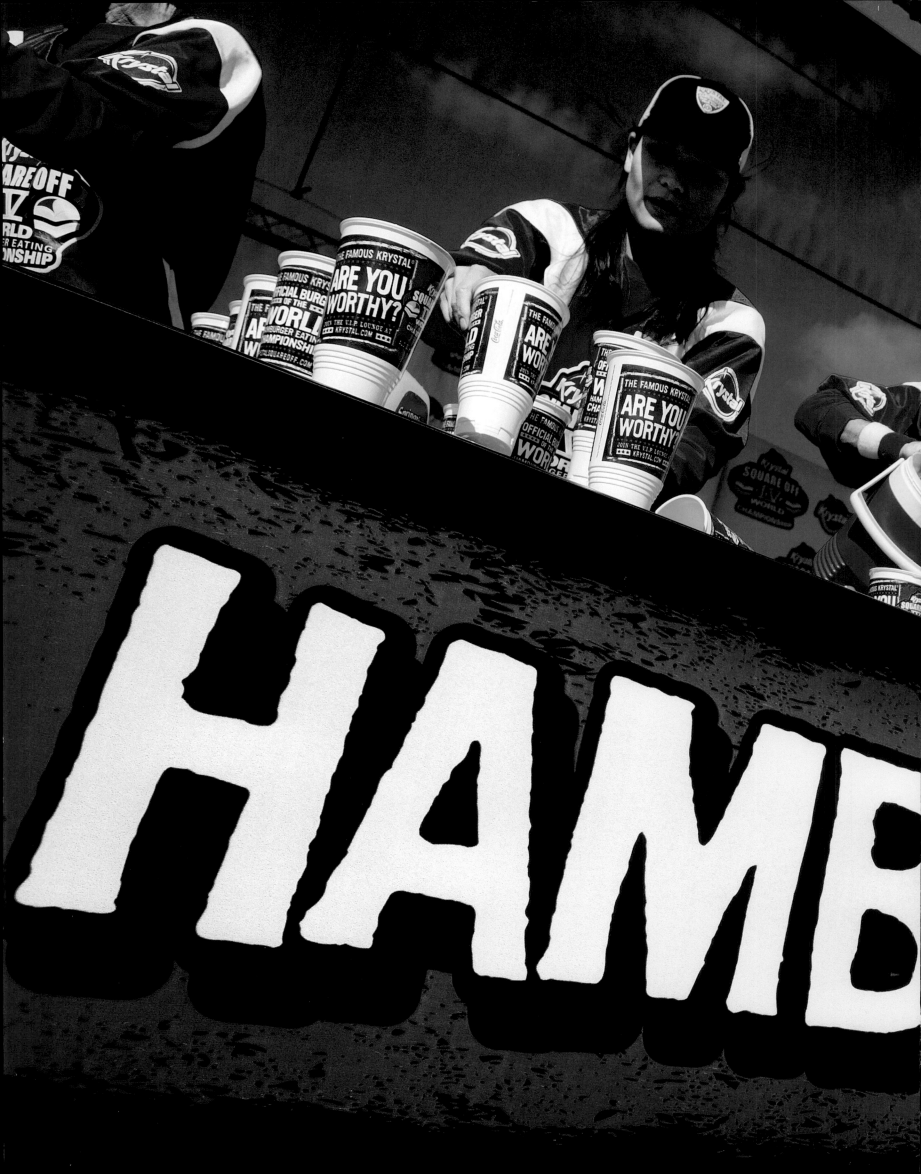

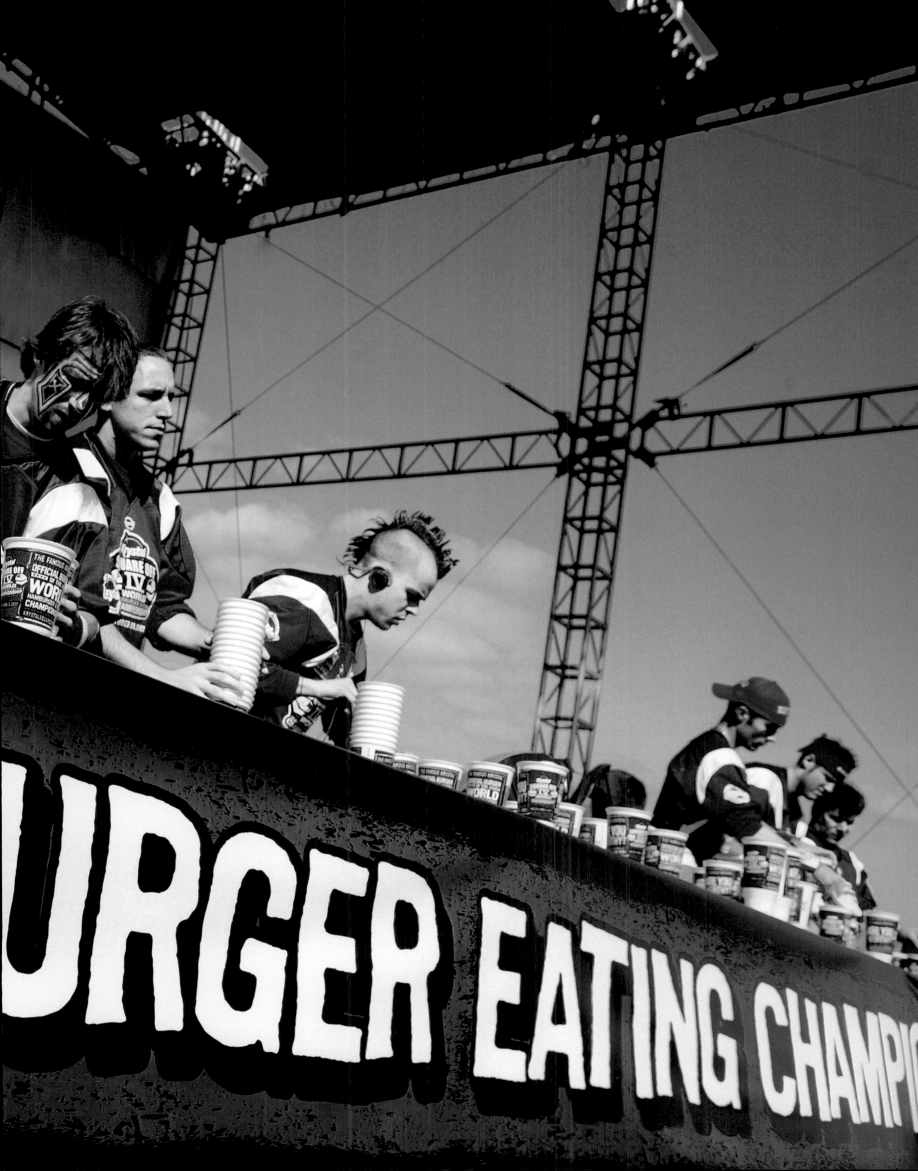

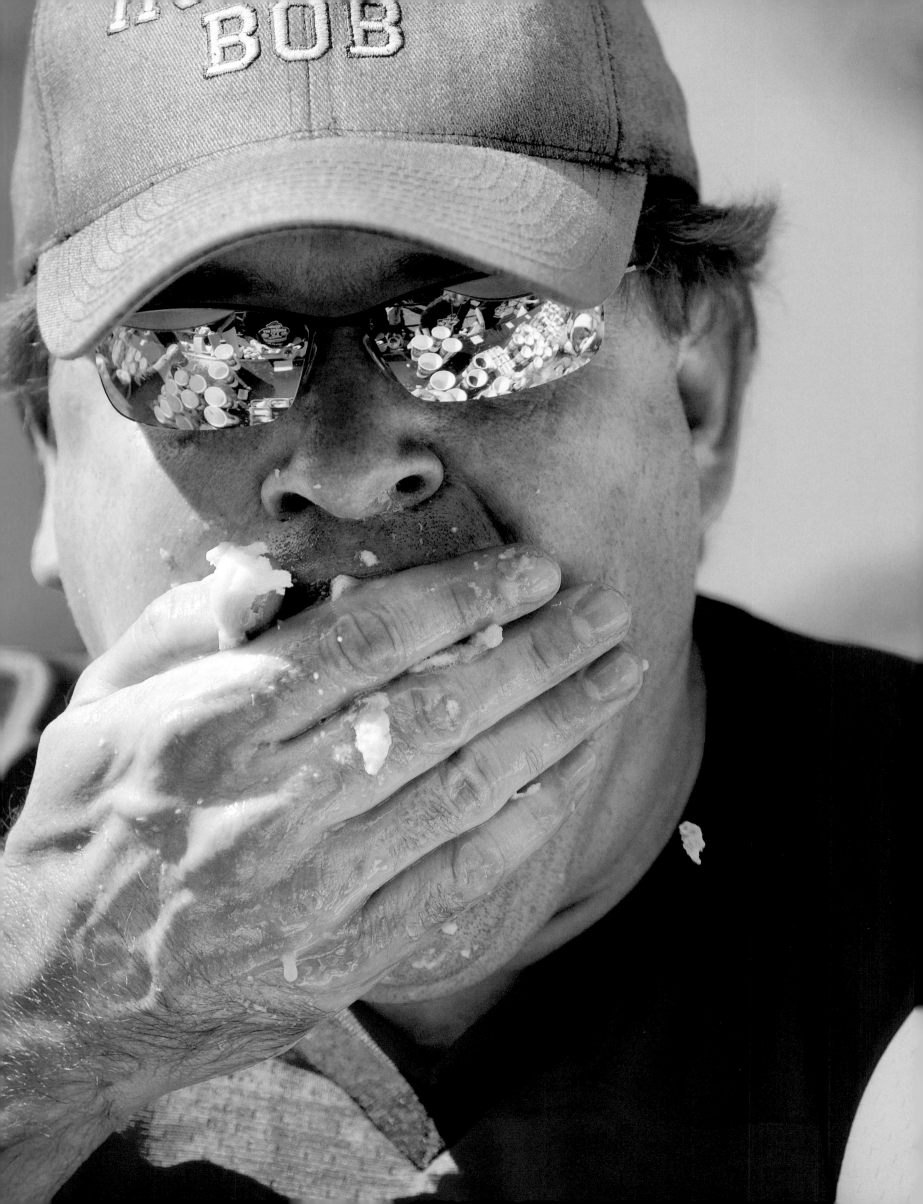

I had hamburger in my
left nostril and I couldn't breathe.
I thought, if the food comes up
I will lose $7,500 and I've spent
all this time getting here.
I have got to keep it down.

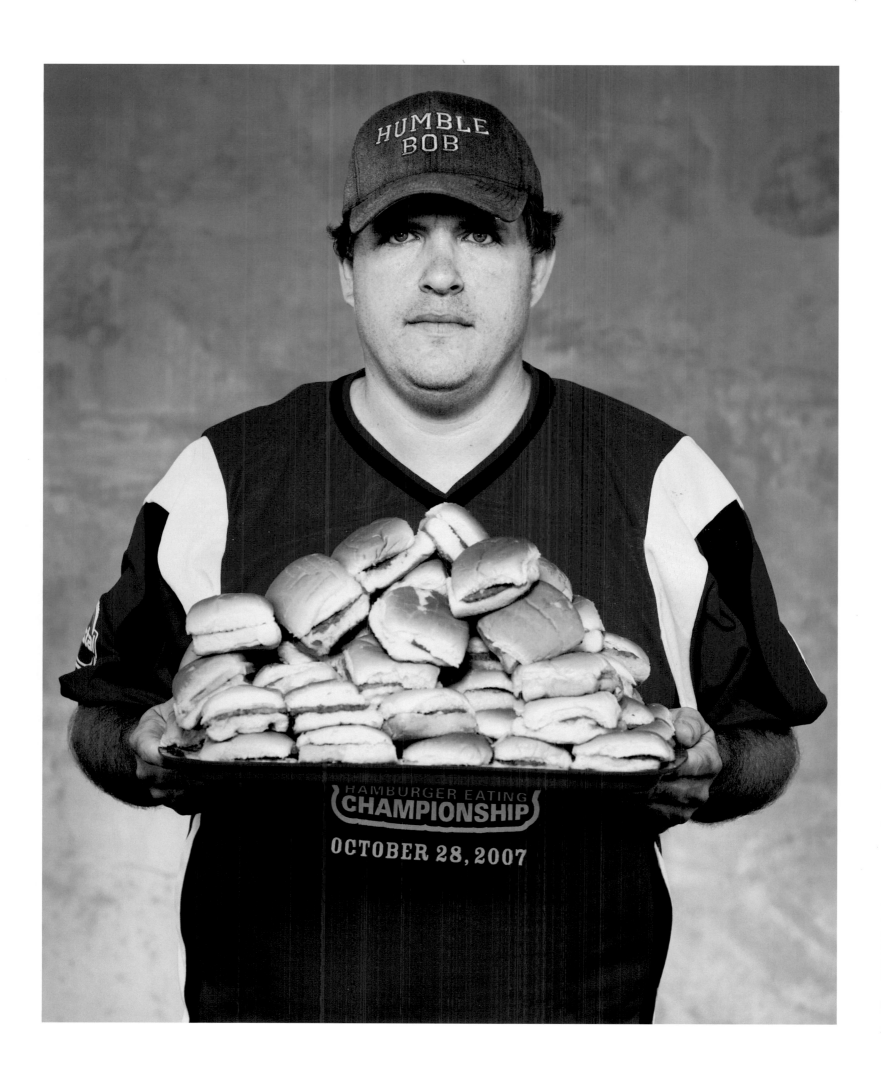

BOB SHOUDT
2ND, WORLD HAMBURGER EATING CHAMPIONSHIP
CHATTANOOGA, TENNESSEE

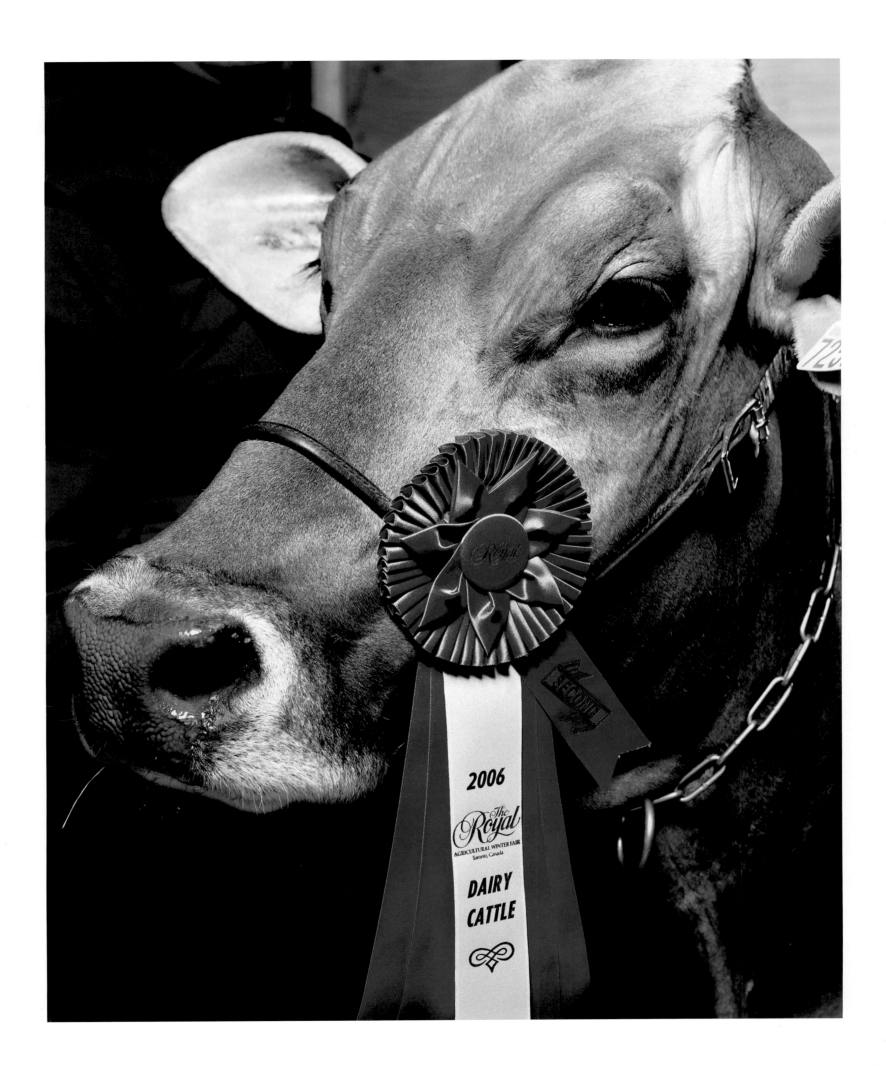

EMPRESS & KEN DRUMMOND
2ND, DAIRY COW, THE ROYAL AGRICULTURAL WINTER FAIR
EXHIBITION PLACE, TORONTO

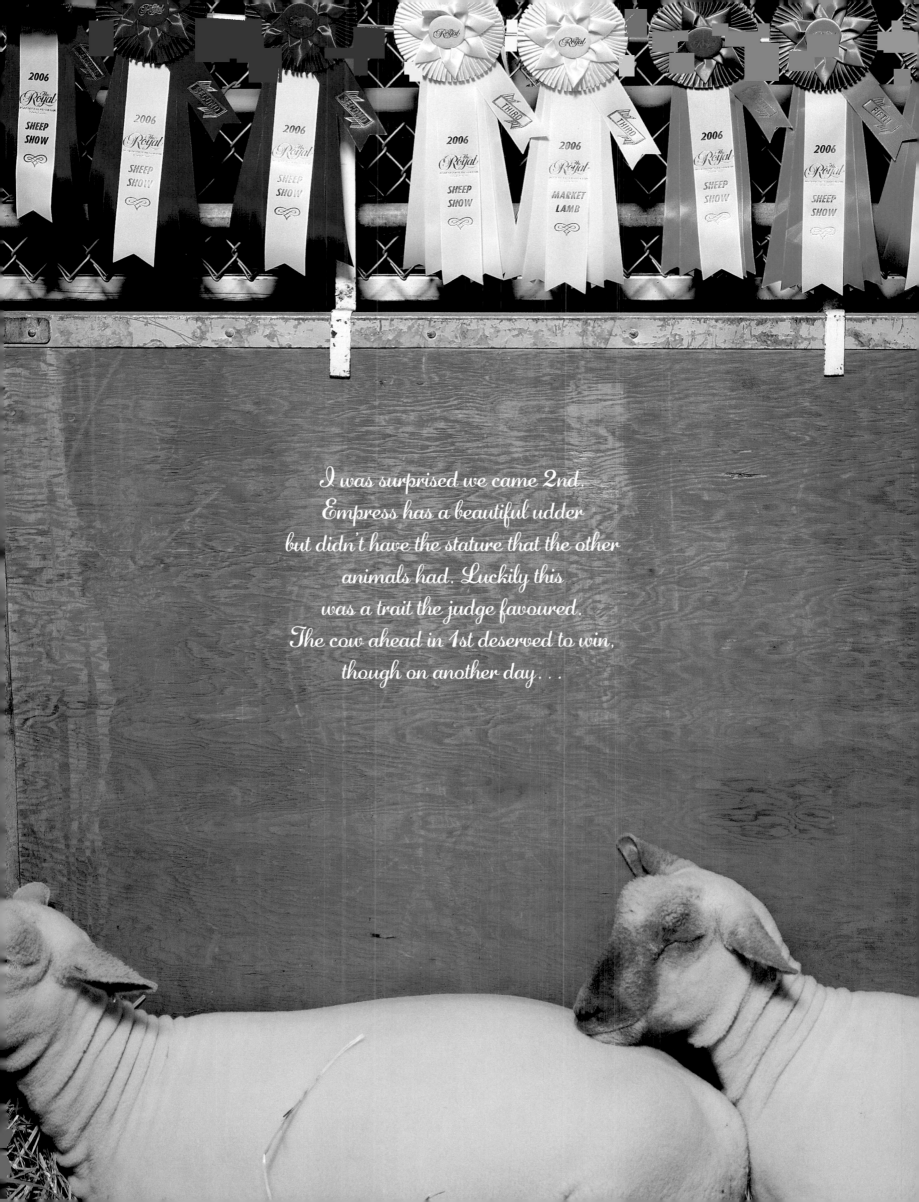

I was surprised we came 2nd.
Empress has a beautiful udder
but didn't have the stature that the other
animals had. Luckily this
was a trait the judge favoured.
The cow ahead in 1st deserved to win,
though on another day . . .

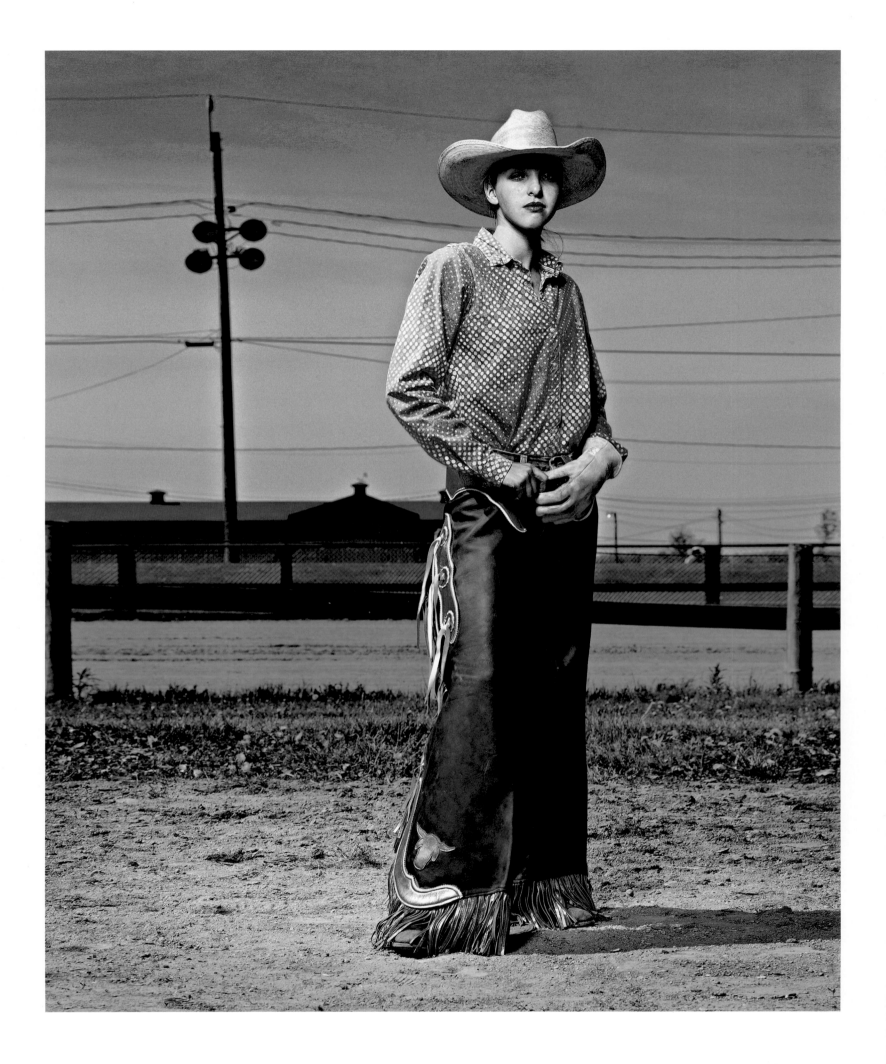

ANYA O'LEARY
2ND, STEER RIDER, RAWHIDE RODEO COMPANY, MARKHAM RODEO
MARKHAM, ONTARIO

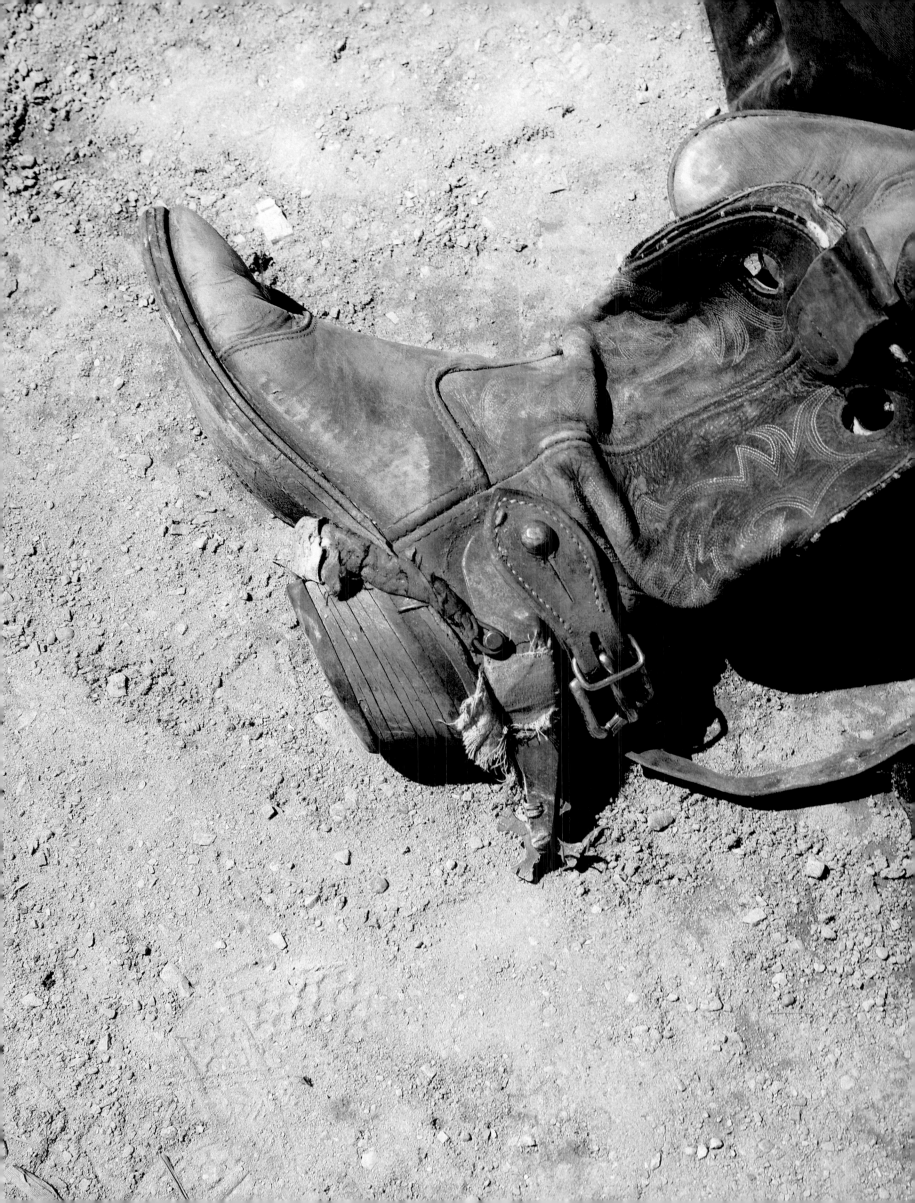

The bull threw me off, stepped on
my face and broke my jaw.
They didn't give me nothing.
They said I should go to the hospital
but I went to the next rodeo
five hours away where I got 1st
in steer wrestling.

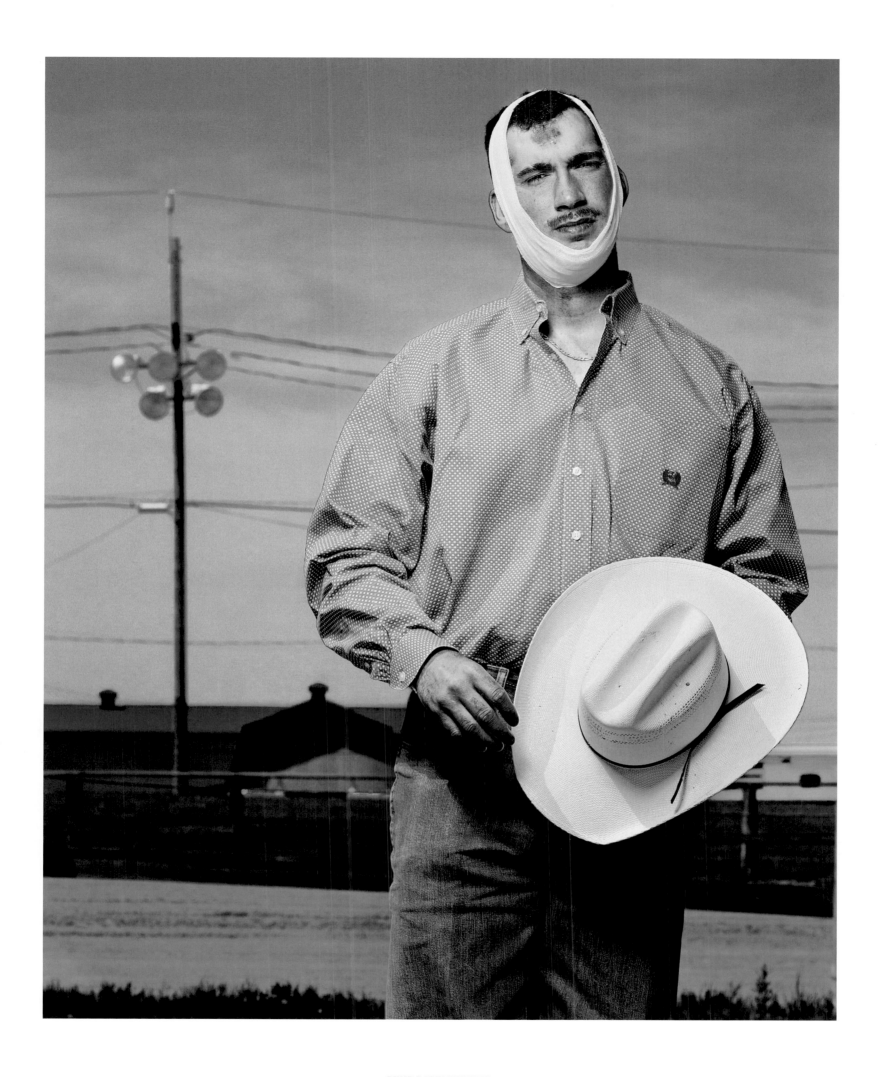

BUMP POSTLETHWAIT
2ND, BULL RIDER, RAWHIDE RODEO COMPANY, MARKHAM RODEO
MARKHAM, ONTARIO

# RACING WEIGHTS
## WENTWORTH PARK

| | 1 | 2 | 3 | 4 | 5 | 6 | 7 | 8 | 9 | 10 | 11 | 12 |
|---|---|---|---|---|---|---|---|---|---|---|---|---|
| **1** | 27.7 | 28.0 | 24.8 | 33.2 | 27.5 | 31.5 | 31.9 | 31.6 | 32.7 | 26.6 | | |
| **2** | / | 32.9 | 30.4 | 27.2 | 33.1 | 30.0 | 28.6 | 33.2 | 26.3 | 27.8 | | |
| **3** | 29.4 | 33.6 | 27.4 | 34.3 | 27.6 | 33.1 | 31.7 | 32.3 | 28.8 | 29.8 | | |
| **4** | 33.5 | 33.9 | 35.7 | 26.5 | 28.6 | 25.5 | 34.0 | 29.5 | 30.5 | / | | |
| **5** | 29.0 | 30.3 | 27.8 | 27.0 | 32.4 | 32.5 | 32.1 | 32.3 | 26.8 | 28.2 | | |
| **6** | 26.8 | 26.7 | 26.8 | 27.5 | 29.7 | 32.8 | 28.8 | 30.3 | 27.3 | / | | |
| **7** | 26.7 | 30.0 | 27.0 | 32.0 | 33.1 | 25.8 | 30.5 | 26.8 | / | 28.8 | | |
| **8** | 26.0 | 28.5 | 32.5 | 26.1 | 30.0 | 29.6 | 25.8 | 27.8 | 26.5 | 26.4 | | |
| **9** | 33.8 | | | | | | | | | | | |
| **10** | | | | | | | | | / | 30.8 | | |
| | | | | | | | | | 26.0 | | | |

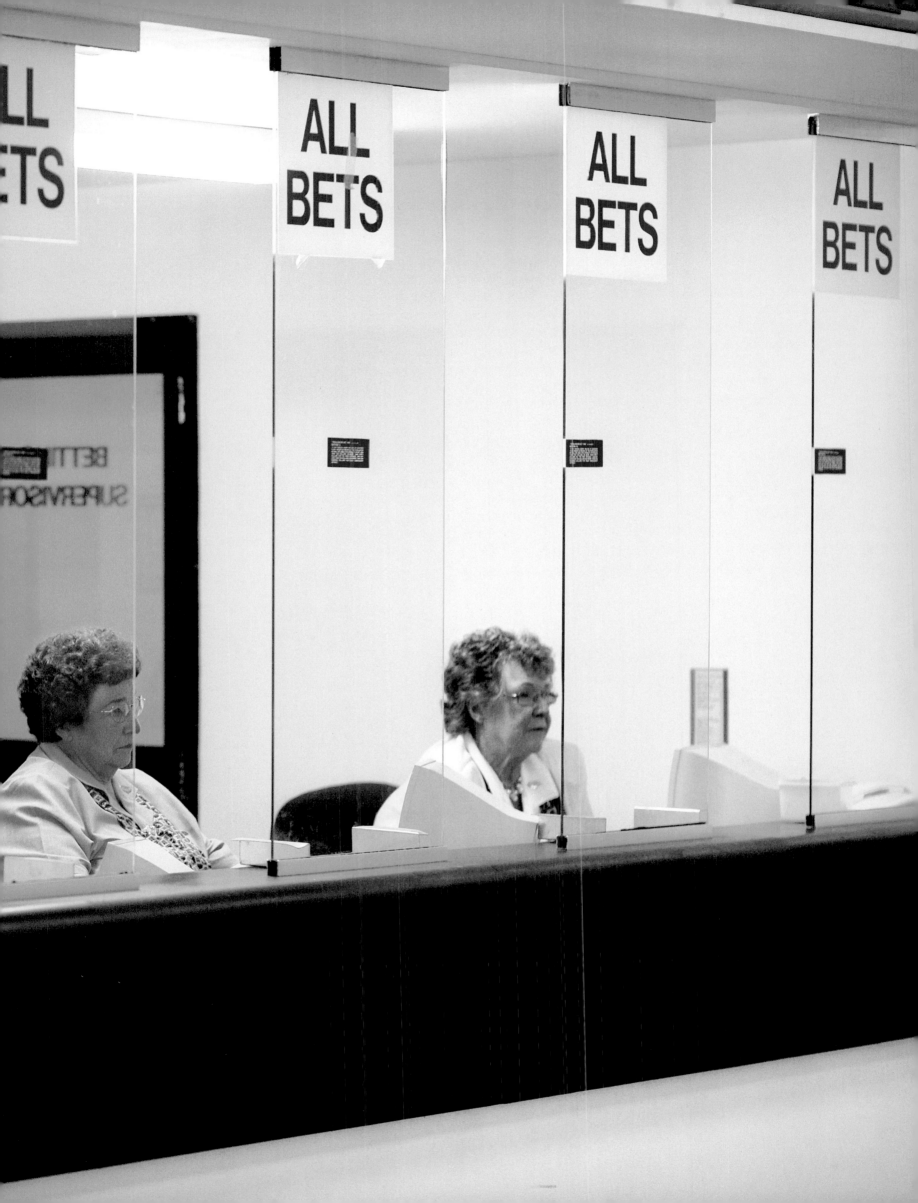

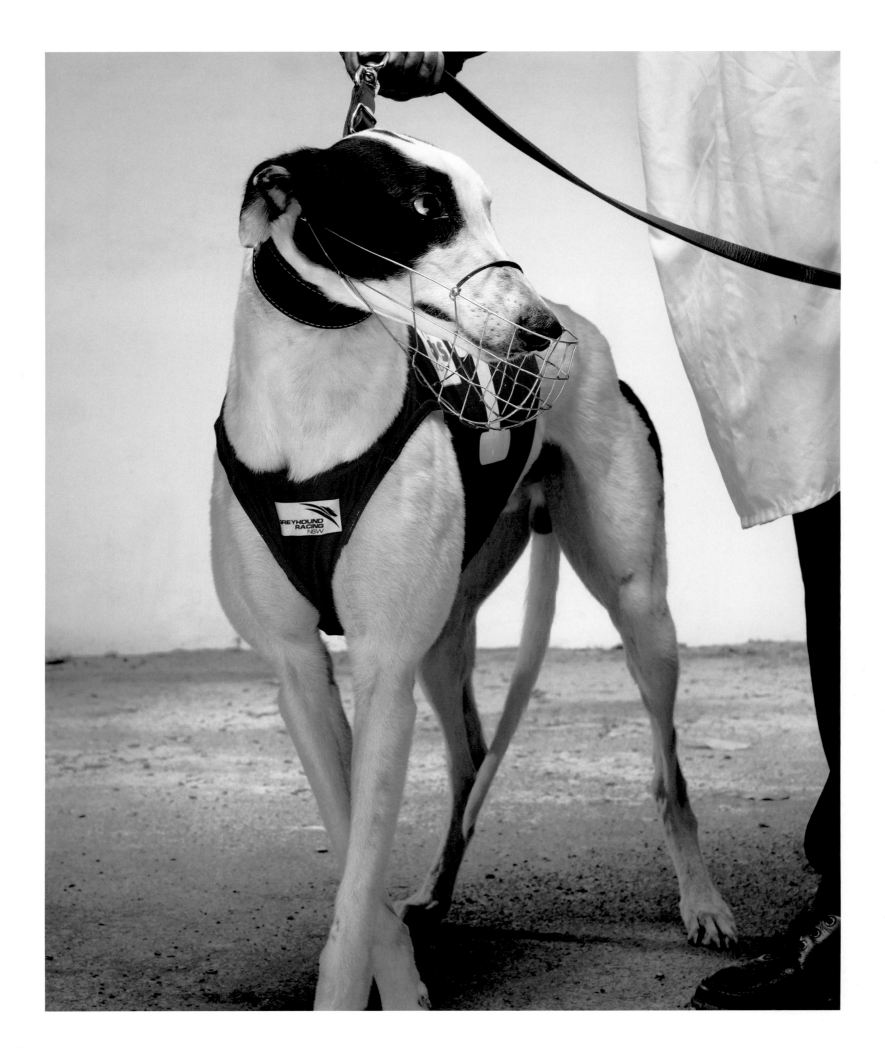

JIBBATHON & HANK VANDERBURG
2ND, GREYHOUND RACE
WENTWORTH PARK, SYDNEY

The dog has gone to Tasmania now.
We decided he is not good
enough. He was not overly strong.
He was an ordinary dog.

CONTACT
NUMBER
FOR
SECURITY
31

There was a guy from
First Lego Robotics who said we were
winning, our progress was going
very well. I was just imagining how great
it would be if we actually won
and went to Atlanta, because I heard
Steve Wozniak was going to
be there. He's one of the co-founders
of Apple computers, kind of a role model
for me. We regretted not coming 1st.

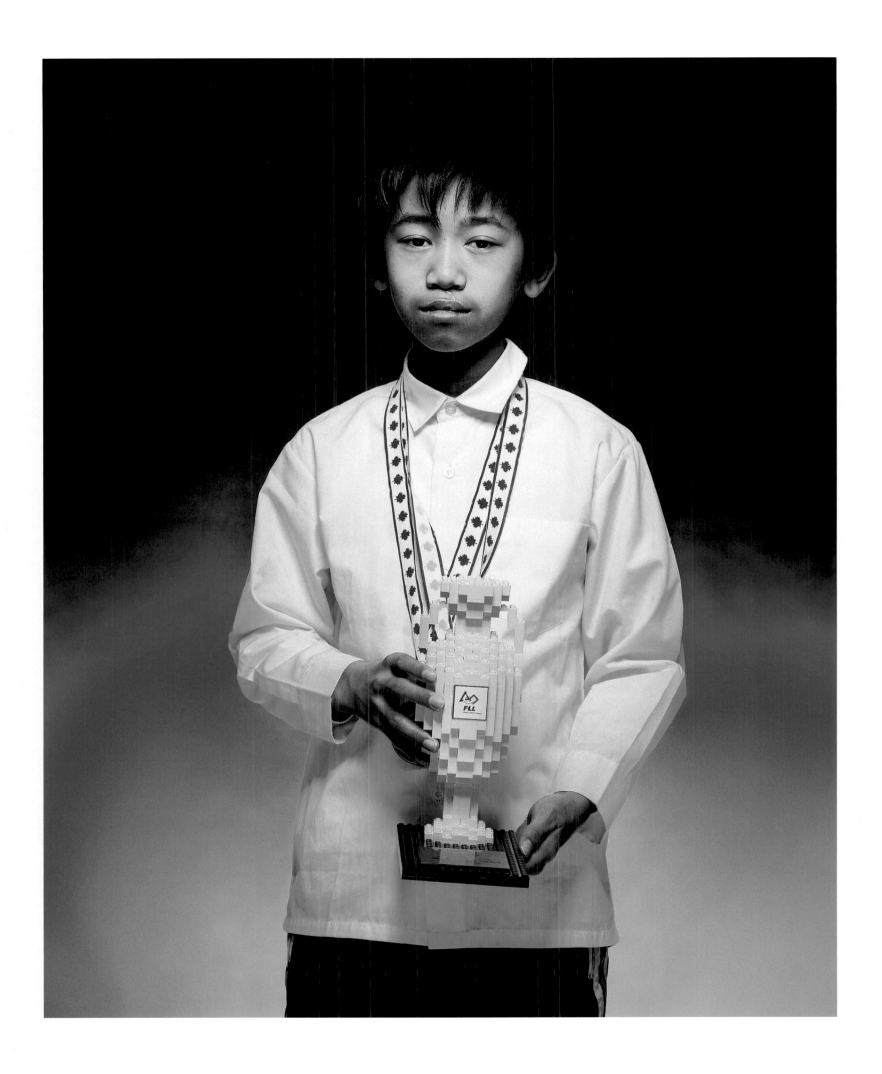

TIM HO, TEAM CYBER STORM

2ND, FIRST LEGO LEAGUE ONTARIO PROVINCIAL CHAMPIONSHIP

ST. MILDRED'S-LIGHTBOURN SCHOOL, OAKVILLE, ONTARIO

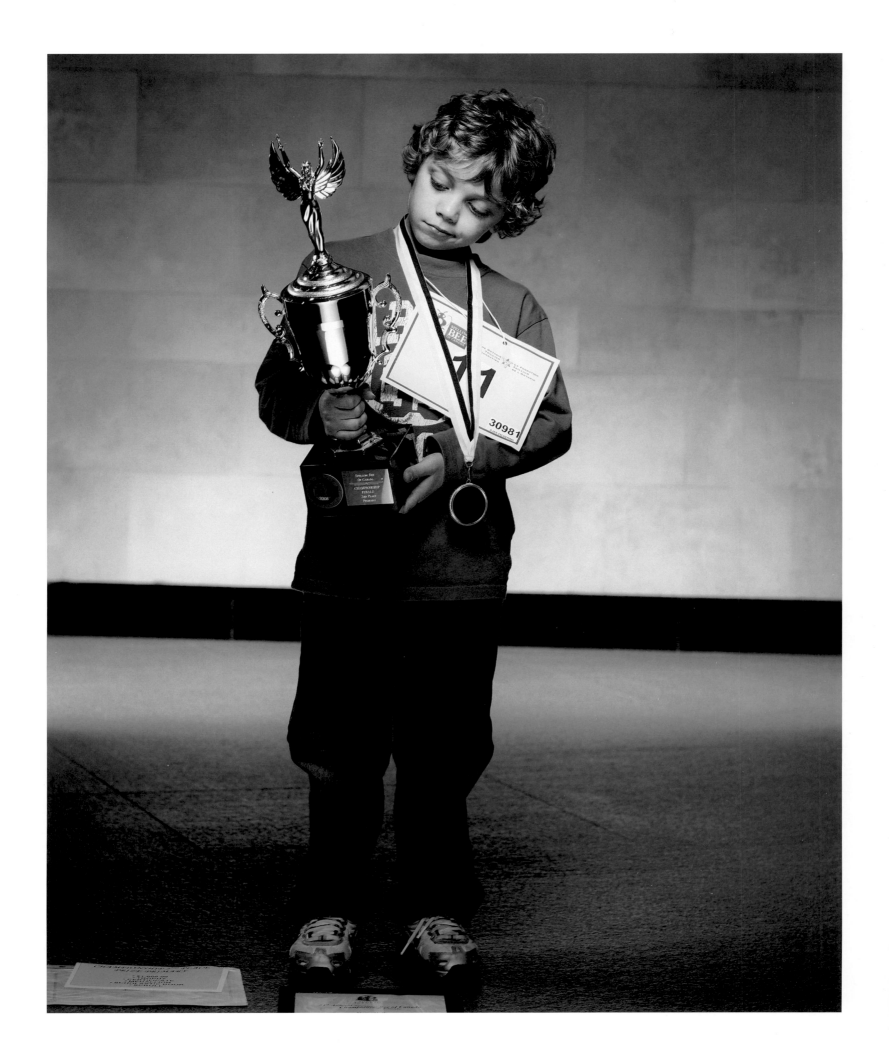

JOSHUA POLERA

2ND, PRIMARY CATEGORY, SPELLING BEE OF CANADA, ONTARIO CHAMPIONSHIP FINALS

CITY HALL, TORONTO

I was in a tie and the
word I got wrong was 'bungalow,'
b-u-n-g-a-l-o-w.
But I spelt it b-u-n-g-a-l-o.
I'm going to remember
that for a really long time. Then
I got 'galore.' I was so
proud of myself, but also kind of
sad because just one word
knocked me out.

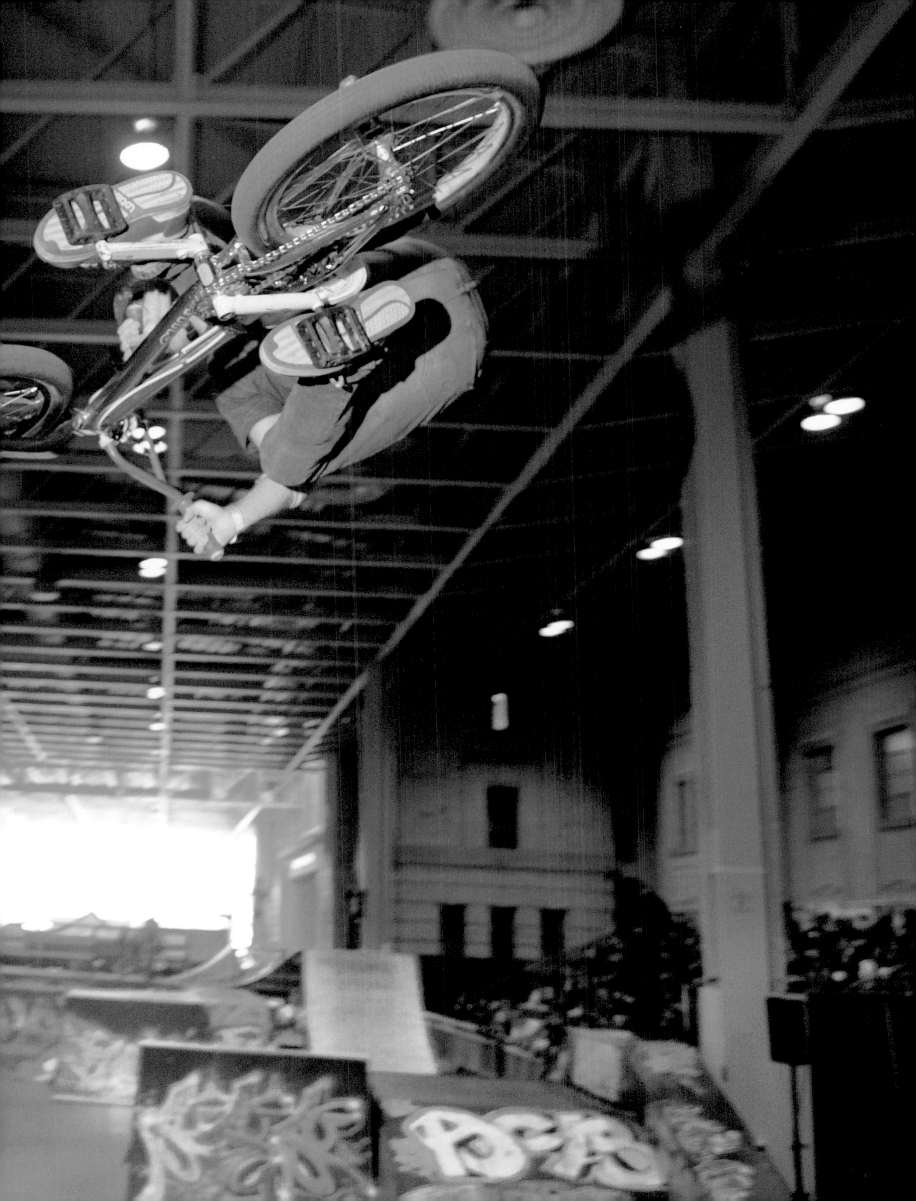

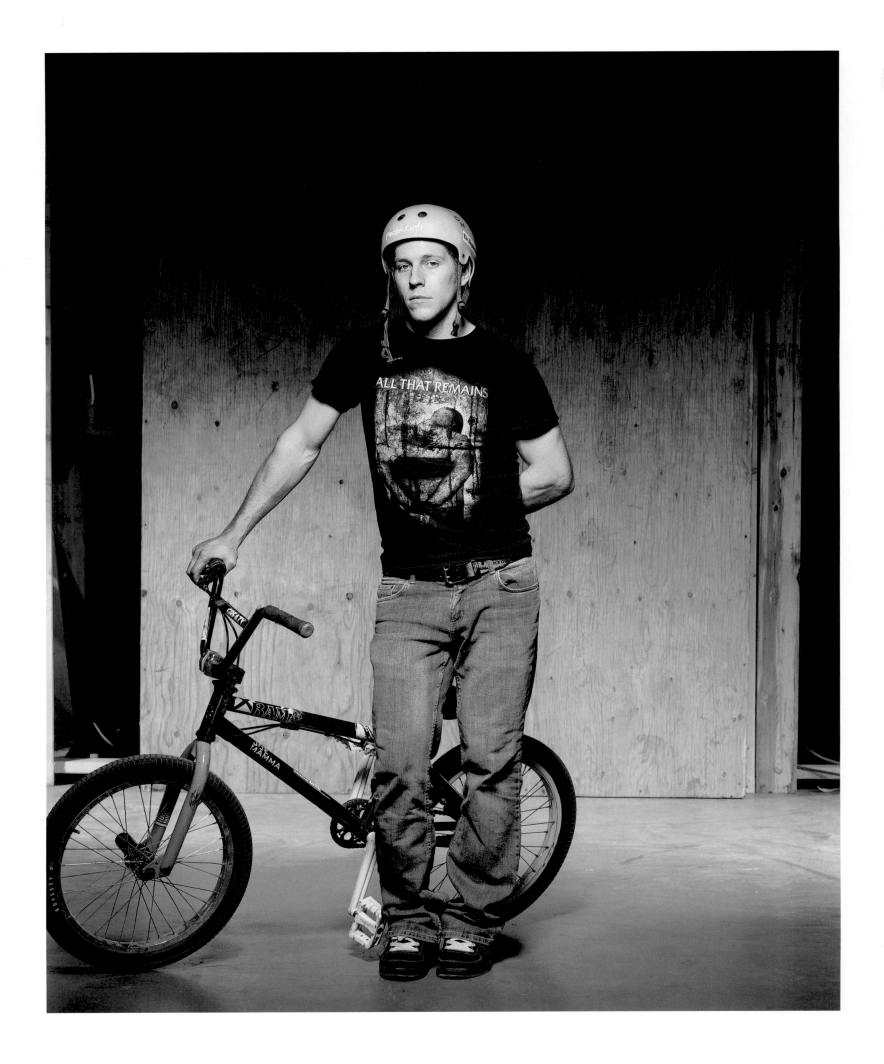

RICH REDMOND

2ND, FREESTYLE AMATEUR BMX, TORONTO BMX JAM

EXHIBITION PLACE, TORONTO

I was pretty happy.
I was happy for my friends
that did well.
Rebecca Smith came 1st.

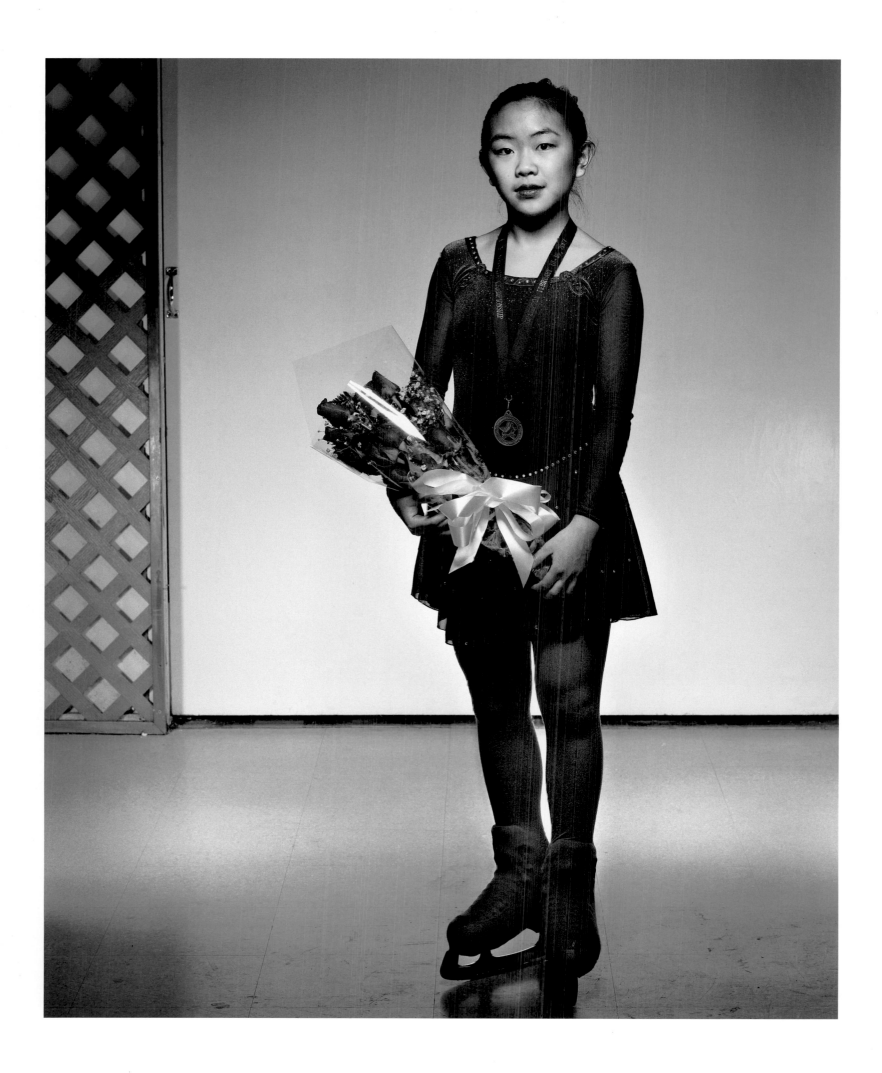

TALYSSA FERRER
2ND, SOLO STAR, SKATE BRAMPTON FIGURE SKATING CHAMPIONSHIP
BRAMPTON, ONTARIO

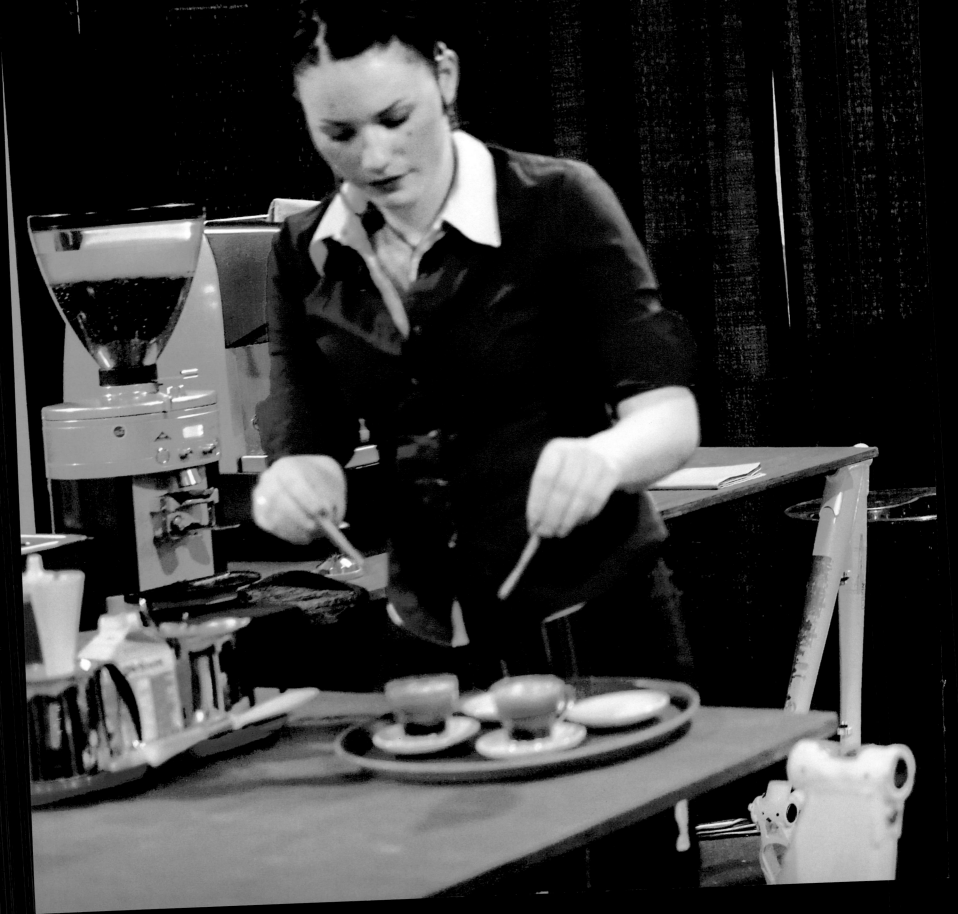

I felt unbelievable. I was too tired—
I had only slept two hours
the night before, I was practicing all night.
I was little bit disappointed,
I was also so happy.
It's really a complicated feeling.

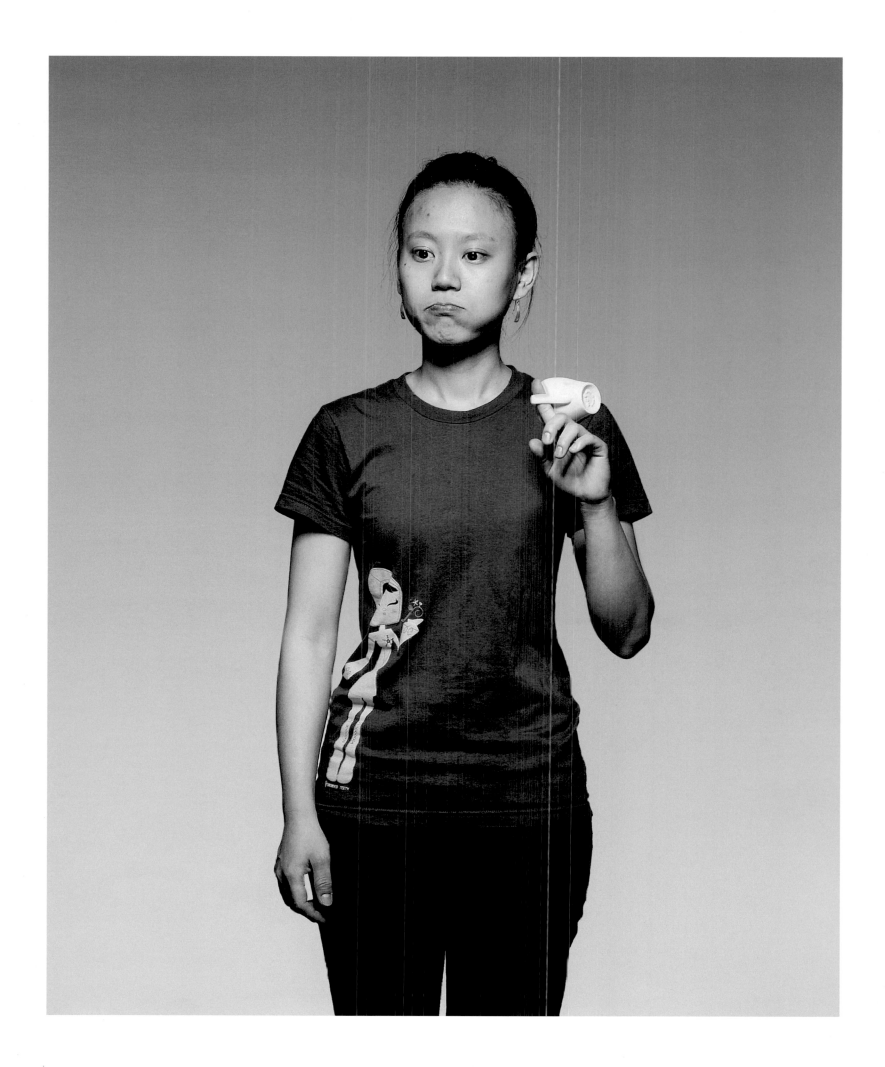

CADY WU

2ND, CANADIAN NATIONAL BARISTA CHAMPIONSHIP, COFFEE AND TEA SHOW

CONGRESS CENTRE, TORONTO

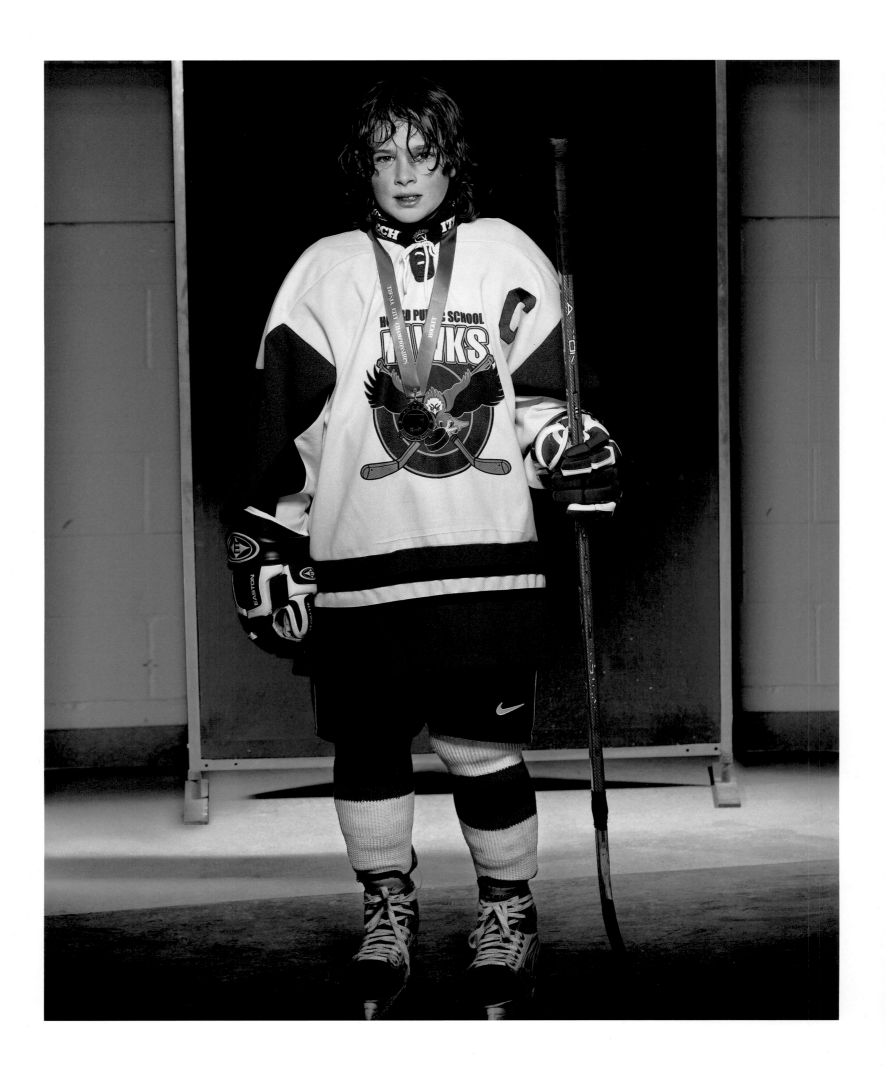

ISAAC BOWMAN, CAPTAIN, HOWARD HAWKS
2ND, TORONTO PUBLIC SCHOOL CITY HOCKEY CHAMPIONSHIP
VARSITY ARENA, TORONTO

The highlight for me
was when we scored our goal.
I got our team's banner,
got my medal, got my
picture taken and we all went
back to school.

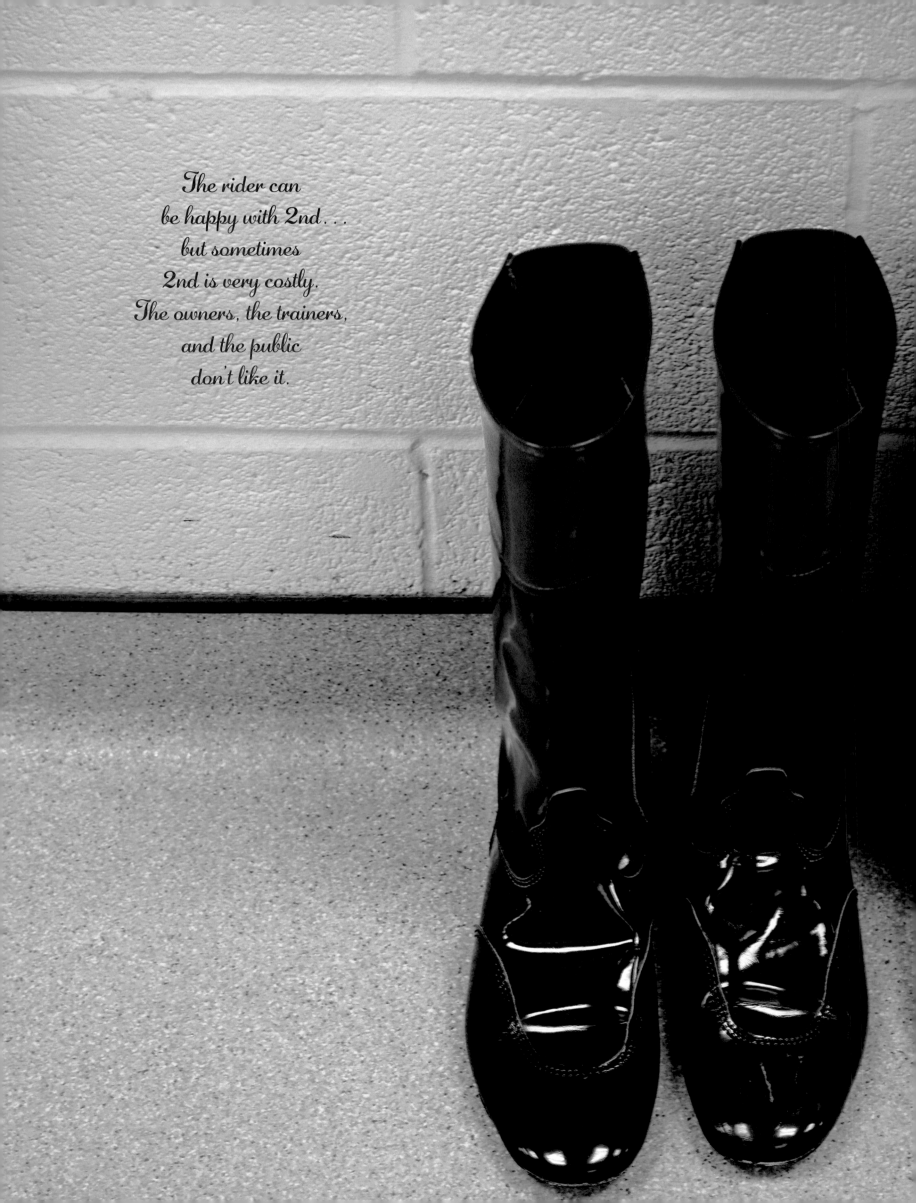

The rider can
be happy with 2nd . . .
but sometimes
2nd is very costly.
The owners, the trainers,
and the public
don't like it.

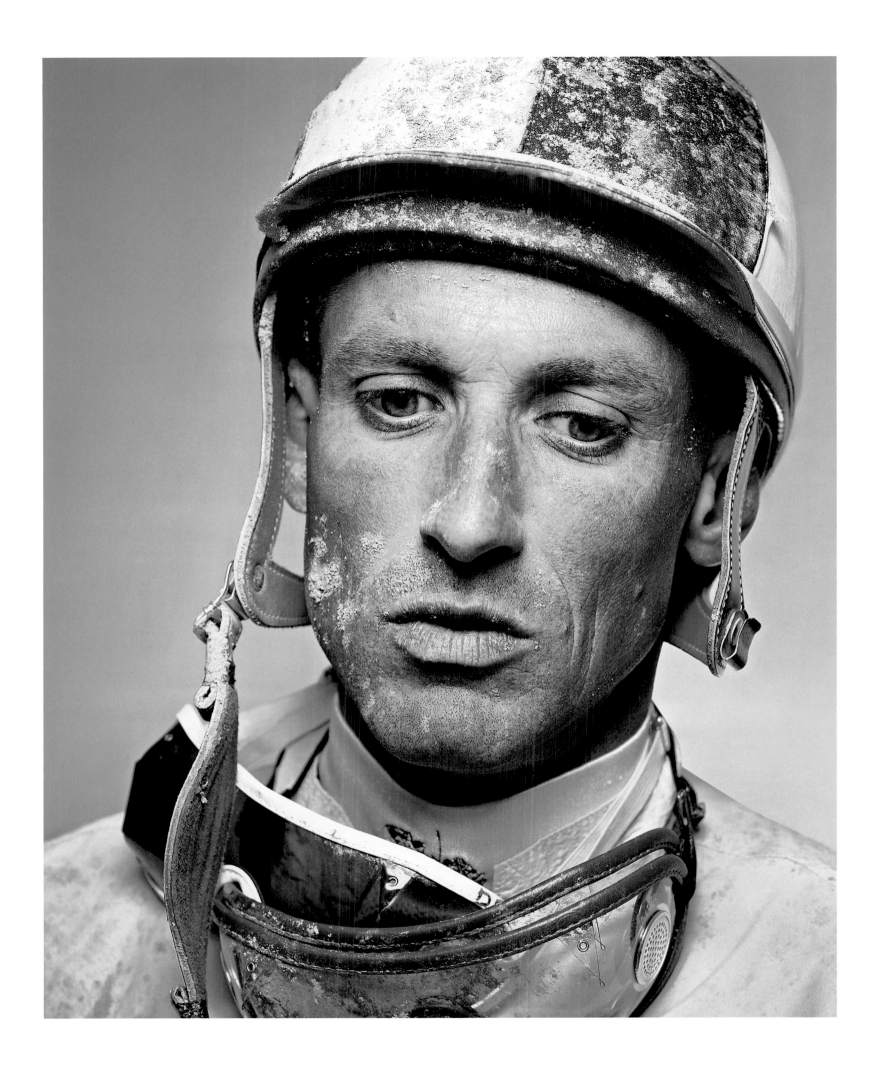

DEAN DEVERELL
2ND, BREEDER'S CUP
WOODBINE RACETRACK, ETOBICOKE, ONTARIO

DAVID BOYS
2ND, CANADIAN NATIONAL SCRABBLE CHAMPIONSHIP
THE ONTARIO CLUB, TORONTO

*I wish I had won, but you know,*
*at the end of the day I did not care that much.*
*I didn't need the glory and*
*I didn't need the money and I'm surprised*
*it was me with that attitude.*

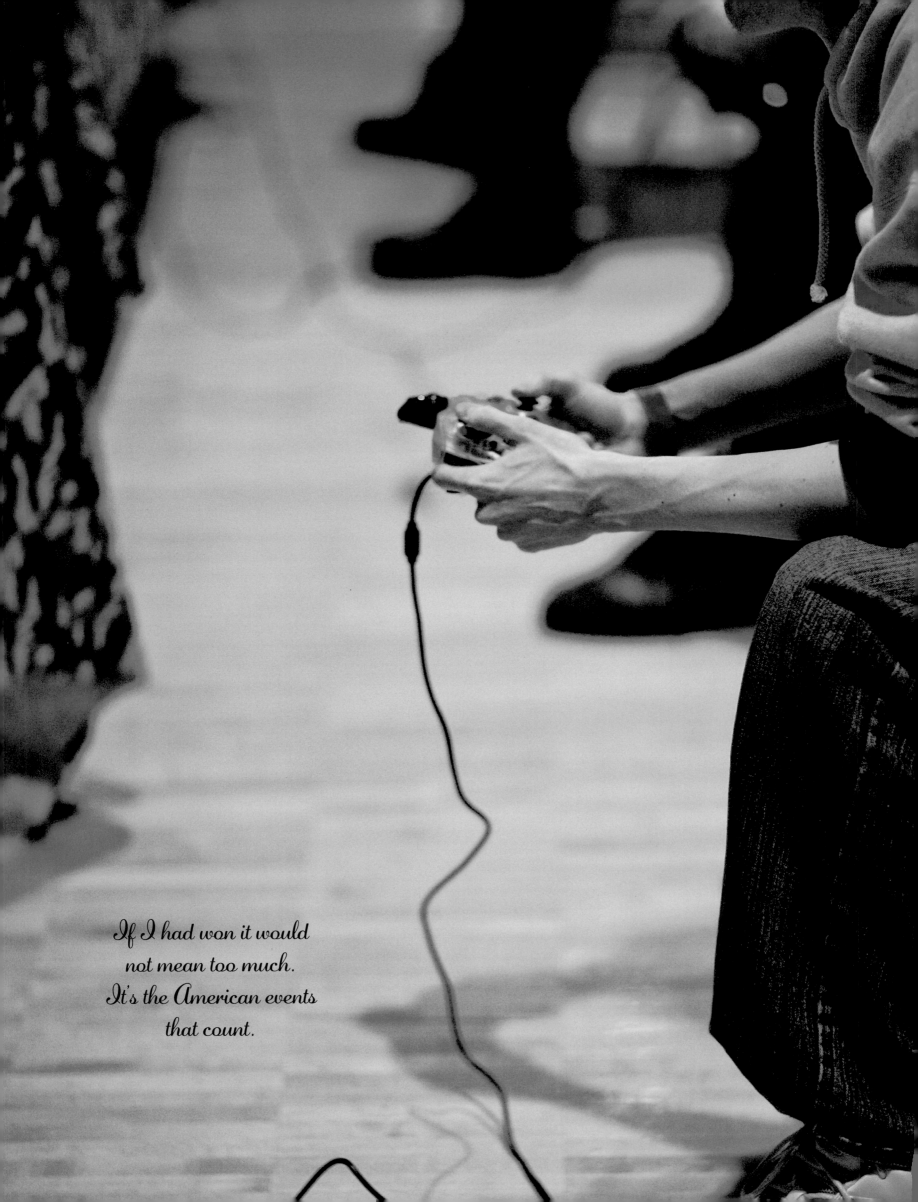

*If I had won it would
not mean too much.
It's the American events
that count.*

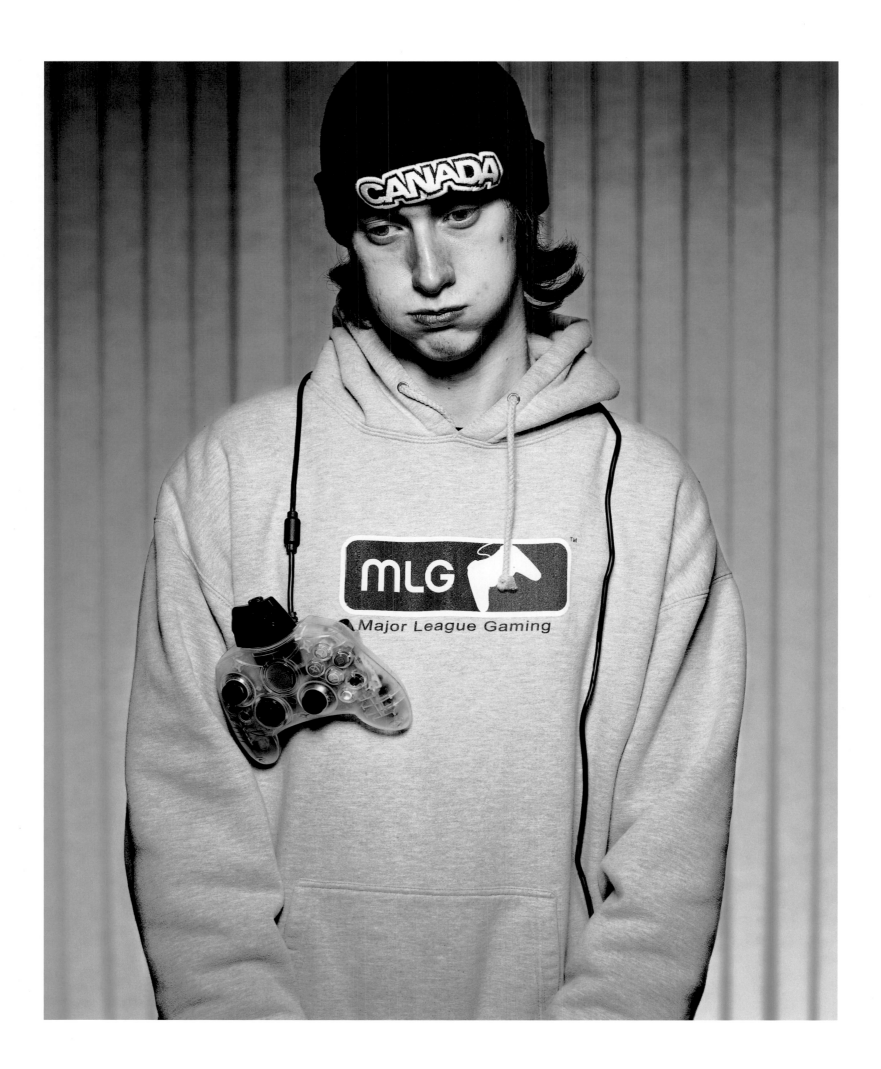

LEO VITELLI, DORK ARMY

2ND, CANADIAN GAME PRO SERIES X-BCX FINALS, MARKHAM GAMING EXPO

MARKHAM COMMUNITY CENTRE, TORONTO

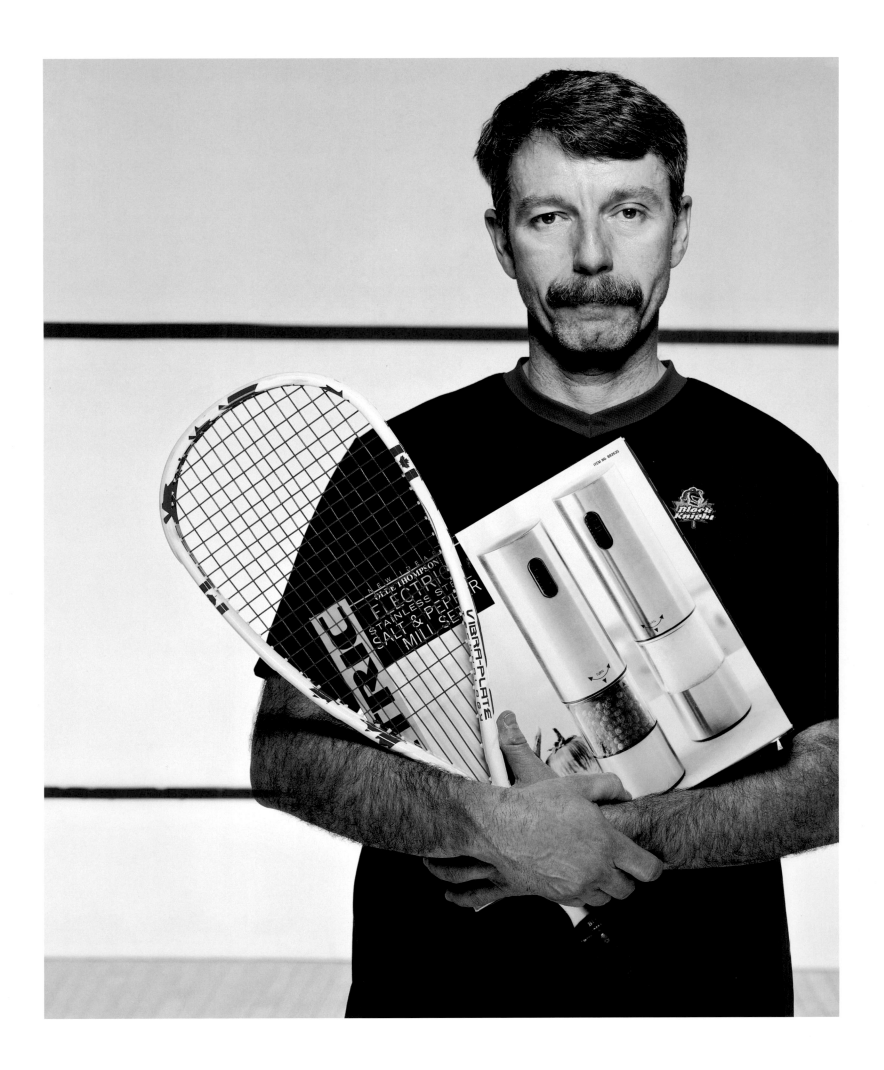

GARY DELAVIGNE
2ND, 45+ ONTARIO SQUASH CHAMPIONSHIPS
THE CLUB AT WHITE OAKS, NIAGARA-ON-THE-LAKE, ONTARIO

My wife was happy with the prize:
the electric salt and pepper shakers.
She has them in the kitchen.
Last year I got some tumblers I think.

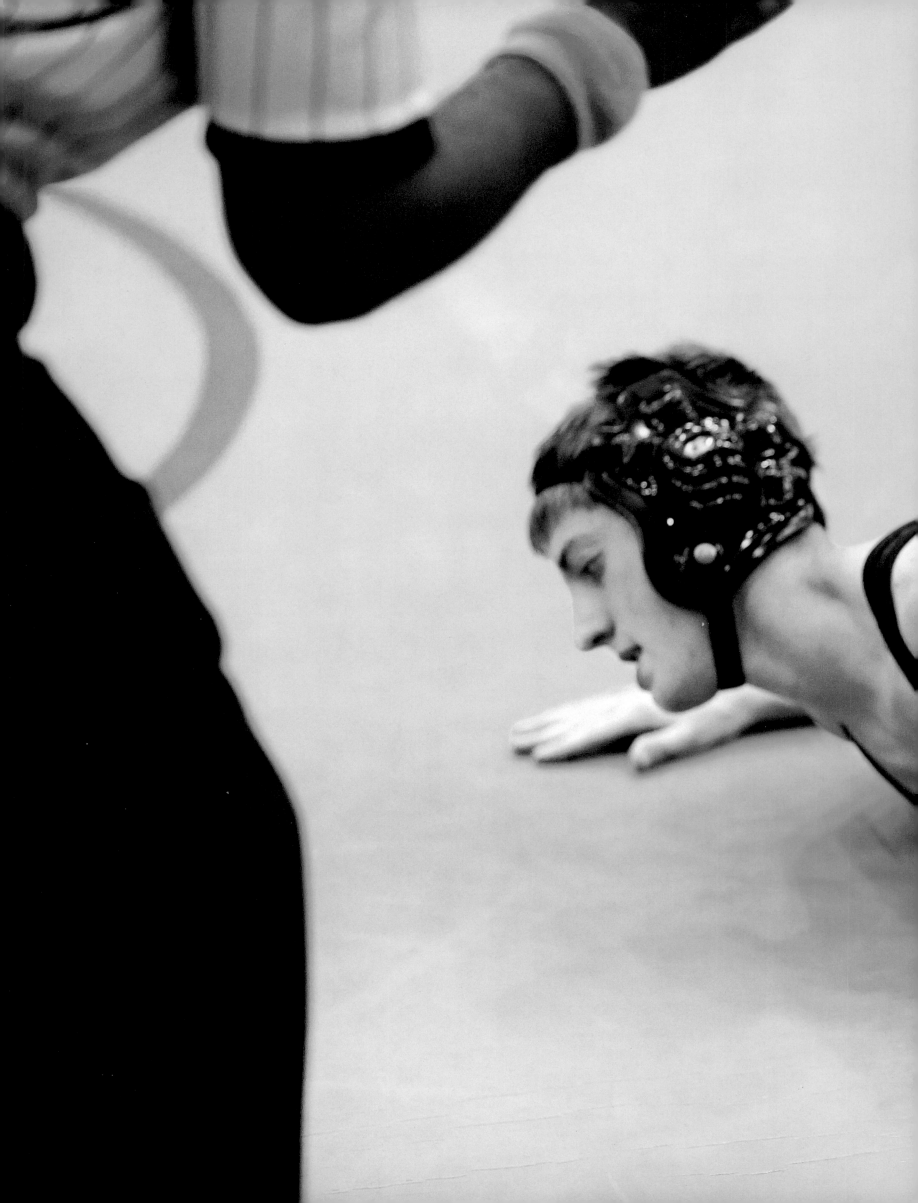

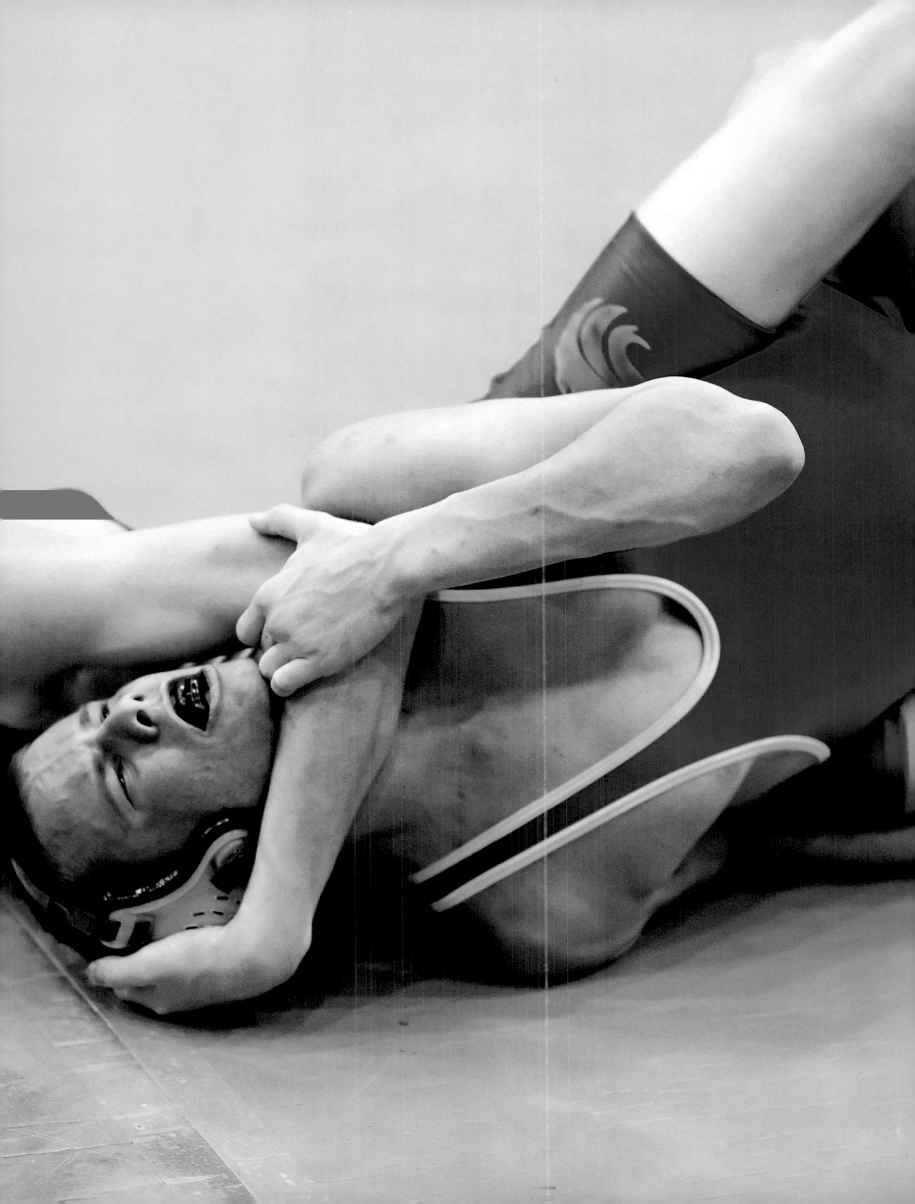

Hopefully, I can get a scholarship
and pay my way through college with wrestling.
When you place higher, you have
a chance of getting into a better college.

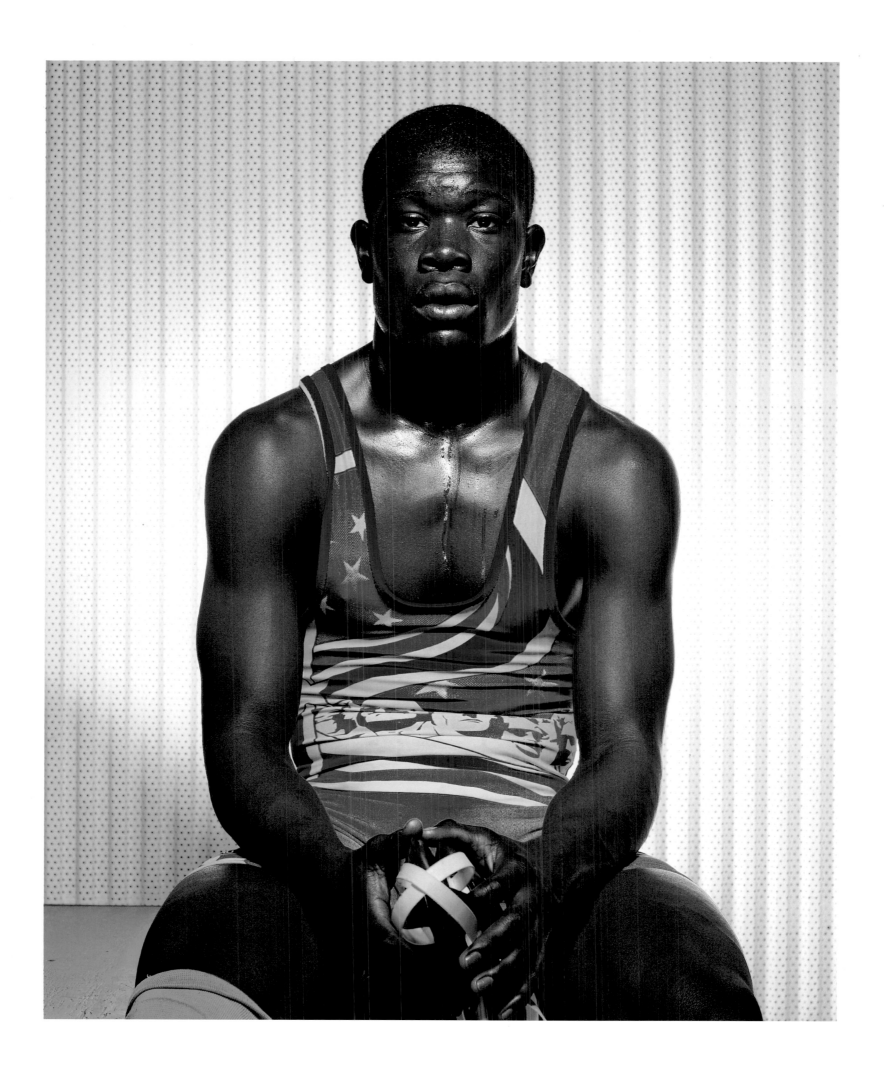

JACOB PARMENTER

2ND, JUNIOR 160 LB, FLORIDA STATE FOLK STYLE CHAMPIONSHIPS

PALMETTO RIDGE HIGH SCHOOL, NAPLES, FLORIDA

A special *thank you* to all the competitors.

Thank you to Coach Carol Devine, Sasha and Veronica of team Nicholson; MaryAnn Camilleri and the squad at The Magenta Foundation; Gilbert Li and Lauren Wickware, the duo at The Office of Gilbert Li; Doug Laxdal and the crew at Gas Company; Anne Desrochers and the troop at Klaxonnez; personal bests from Keith Haist, Aaron Hoskins Igor Yu, John and Kate Gollings, Meg and Garth Nicholson, Mickey and Marge Devine, Action Trophy, Tatar Gallery; and last but not least, Lee McLaven of Laven Industries Ltd.

Making a book takes a team. Sincere thanks to everyone who contributed in many ways.

First Edition 2008
© 2008 The Magenta Foundation

**PHOTO EDITORS**
MaryAnn Camilleri, Clare Jordan

**EDITOR**
Doug Wallace

**PROOF READERS**
Michaela Cornell, Craig D'Arville

**DESIGN**
The Office of Gilbert Li

**PRE-PRESS**
The Gas Company

**PRINTING**
1010 Printing International (China)

**RIBBON**
Dominion Regalia

Library and Archives Canada Cataloguing in Publication

Nicholson, Sandy, 1973–
       2nd: the face of defeat / photographs by Sandy Nicholson; foreword by Susan Bright.

ISBN 978-0-9739739-4-5

1. Nicholson, Sandy, 1973– 2. Contests—Canada—Pictorial works.
3. Contests in art. 4. Photography, Artistic
I. Title   II. Title: Second.

TR655.N53 2008   779.092   C2008-903435-X

Distributed in North America by
Consortium Book Sales and Distribution
cbsd.com

Distributed outside North America by
Thames and Hudson Ltd.
thamesandhudson.com

The Magenta Foundation
151 Winchester Street, Toronto, Ontario, Canada, M4X 1B5
magentafoundation.org

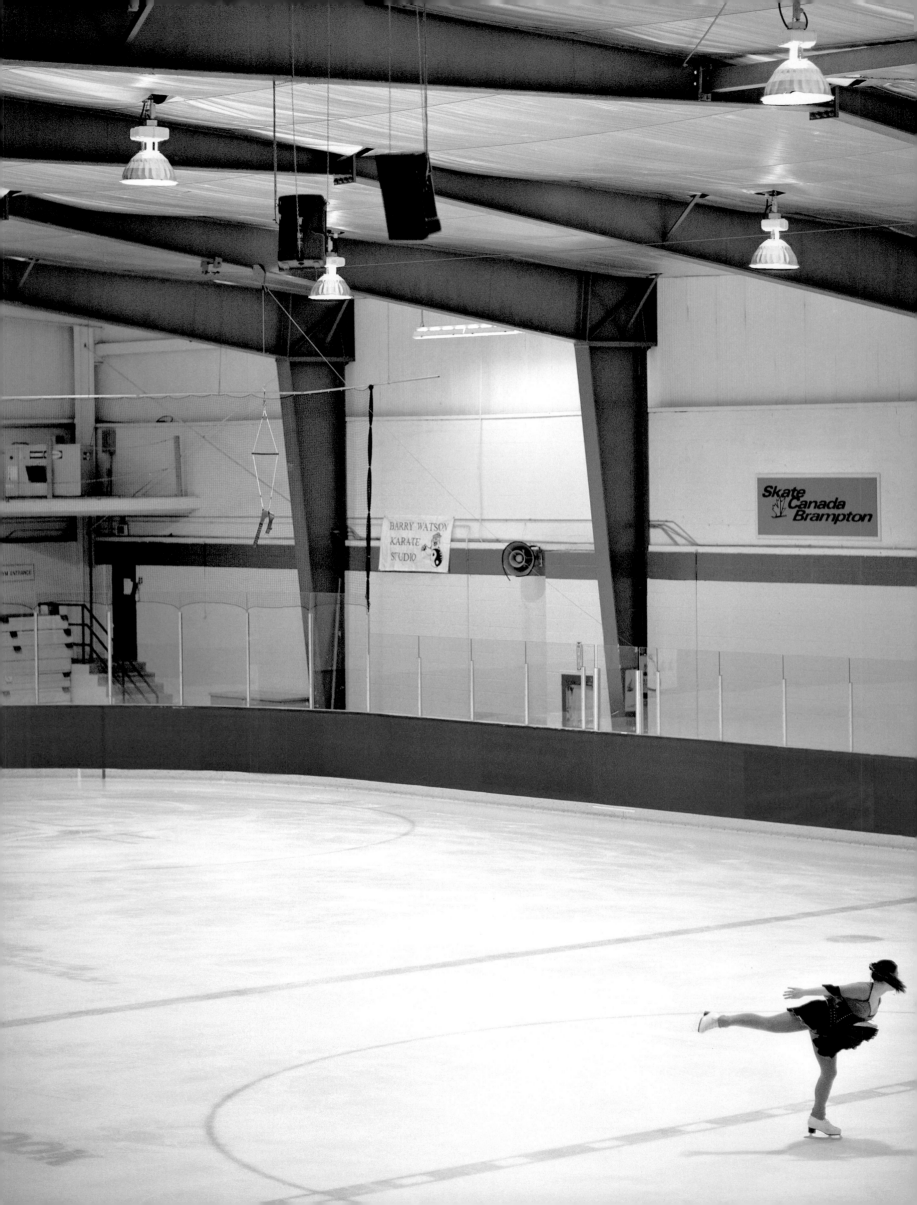